The Joy of Drawing

The Joy of Drawing

Bill Martin

WATSON-GUPTILL PUBLICATIONS
New York

This book is dedicated to my muse, my wife.

Copyright © Bill Martin

First published in 1993 in the United States by Watson-Guptill Publications, a division of BPI Communications, Inc., 1515 Broadway, New York, New York 10036

Library of Congress Cataloging-in-Publication Data

Martin, Bill.
 The joy of drawing : how to draw anything you see (or imagine!) / Bill Martin.
 p. cm.
 Includes index.
 ISBN 0-8230-2370-2 : (pbk.)
 1. Drawing—Technique. I. Title.
NC730.M293 1993
741.2—dc20 93-9265
 CIP

Manufactured in Mexico

1 2 3 4 5 / 97 96 95 94 93

CONTENTS

GETTING STARTED

We know what we see, but we don't always know *how* we know what we see. When we look out the window, how do we know how far away a particular tree is? Or, how do we know how steep a hill is? And, how do we distinguish one texture from another without ever touching them? We know from experience—experience based on a lifetime of interpreting specific visual clues. If an artist knows what these clues are and how to use them, the illusions he or she creates will be very convincing.

Our visual perception of reality is a rather complex phenomenon. However, it can be separated into relatively few concepts that, once learned, afford the artist a much greater understanding of what is seen and what is to be depicted.

Just as writers must learn to organize their thoughts into words, sentences, paragraphs, and chapters, artists benefit from learning

the language of form, color, texture, shadow, image, and composition to better organize and communicate their thoughts.

By reading this book and doing the exercises at the end of each chapter, you will learn the perceptual clues our eyes and minds use to interpret the surfaces, textures, sizes, forms, and spatial relationships of all things in the world around us, and how to use these clues to communicate your perceptions and imaginings to others through drawing and painting.

There are many rules in this book, yet they represent only some of the options available to the artist and should not be interpreted as either exhaustive or absolute. Rather, the artist can and should go wherever imagination leads.

In this book I present my method of drawing; there are many others, and you will evolve your own. But until you do, I will lend you mine.

Materials

Virtually anything can be called into service to make a drawing. The artist's imagination and invention are the only limitations. In art school we drew with stale coffee, using the chewed end of a matchstick as a brush. There are, however, more traditional materials, ones that have served the most purposes for most artists over time. This very brief survey is simply meant to give you something to work with as the book proceeds; I encourage you to explore many different materials, a process that can be the source of inspiration.

Paper

More drawings are made on paper than on any other surface. The papers fine artists use most often are classified by surface texture, of which there are three types: *hot-pressed* papers, which have a smooth, hard, nonabsorbent surface well suited to pen and ink; *rough* papers, which are well suited to charcoal and pastel; and *cold-pressed* papers, which are medium-textured and best for pencil. Water media (wash, watercolor, gouache) are most frequently used on cold-pressed papers.

Pencils

Artist's pencils come in a great variety of hardnesses, identified by a number and letter code on the shaft. An HB or an F is medium hard and produces a medium-gray mark. An H pencil is harder than an HB. It will produce a lighter gray mark and will hold its point longer. A 2H pencil is harder still and gives an even lighter gray. The H pencils go up to a 10H, a pencil so hard some people say you only have to sharpen it once. The B pencils are softer than the HB and produce a darker mark; their leads get softer and blacker as the numbers go up. An 8B is the darkest and softest. The softer leads tend to break and are therefore thicker. A way to tell the softness or hardness of different pencils is to look at the thickness of the leads; the thicker the lead, the softer it is and the darker its mark. An easy way to remember the pencil code is this: "H" stands for hard, "HB" stands for hardly breaks, and "B" stands for breaks easily.

You can work with pencils in either of these ways. In one approach, you divide the subject of your drawing into values of gray and use a variety of pencils to render these values—harder pencils for light values, softer pencils for dark ones—applying a uniform degree of pressure. The other approach, and the one I favor, is to vary the pressure on whatever pencil you are using to create the value range—lighter pressure for lighter marks, heavier pressure for darker ones. This method works best with an HB or softer pencil so that a wide range of values is possible. To achieve a finer coverage or a more distinct edge in dark values, you can go over an area created by a soft, dark pencil with a harder pencil. This manipulates the marks already on the paper.

For small drawings and my ceaseless doodles, I find a 5-millimeter mechanical pencil (which uses a clicker to advance the lead) very useful because the point never needs sharpening. The 5-mm leads are available in a wide variety of hardnesses.

Charcoal

Charcoal is probably the oldest drawing material, first used by prehistoric cave dwellers. It is incompletely burned wood—the same as the leftovers of your camp fire. Charcoal is generally used on rough paper and can produce a wide range of light and dark and thick and thin marks. There are two types: vine charcoal and compressed charcoal. Vine charcoal is usually made from willow branches and looks like a blackened stick. Softer, lighter, and easier to erase than compressed charcoal, it is used on medium- or rough-surfaced papers. Compressed charcoal is finely ground charcoal compressed into a stick or into leads for use in charcoal pencils. It is used when greater contrast or control is desired. Both kinds of charcoal are available in various degrees of softness (the softer, the darker) and can be used together.

Fixative

Pencil and charcoal drawings are vulnerable to smearing. If you want to preserve your drawings, you should mount them under glass and/or use a fixative. Fixative is a form of varnish that seals the graphite or charcoal to the paper. It is applied by spraying. There are two kinds, gloss and workable; both are suitable for preserving finished art. The gloss type leaves the paper's surface slick, meaning

you can't add to your drawing after applying it. Workable fixative, however, lets you renew the surface of a drawing—isolate a layer—when the buildup of graphite or charcoal is so great that it becomes difficult to add more. But, because fixative prevents smearing, it also prevents erasures; thus, marks that have been fixed are permanent.

Erasers

There are four types of erasers that artists commonly use. They are the kneaded eraser (usually a gray color), the rubber eraser (usually pink), the art gum eraser (usually a tan color), and the plastic eraser (usually white). All of these will effectively remove unwanted marks from your drawing. The most unusual of these is the kneaded eraser, which can be molded like clay into whatever form you need to efficiently erase a particular area; to clean this type of eraser, you simply knead it as you would bread dough. The kneaded eraser, the art gum eraser, and the plastic eraser have the least harmful effects on paper. An art gum eraser is best for removing light marks and smudges; for hard-to-remove marks the pink rubber eraser is most effective.

When your eraser is too large to remove small errors, you can use an eraser shield, a thin sheet of metal with convenient openings of different shapes to erase through. Homemade paper shields can also be used to isolate areas to be erased.

Pen and Ink

Pen and ink is another traditional drawing medium. Pen holders with various nibs (pen points) come in a wide variety of shapes, sizes, and flexibilities. The more flexible the nib, the greater the variation in line thickness. I recommend you try several types to see which suits your style. When I draw with a dip pen, I have a scrap of paper close by to test the stroke after dipping to prevent surprises, such as having too much ink.

When working in this medium I prefer to draw with a fountain pen because it eliminates the need to dip the pen in ink every few moments. I find a gold-plated steel point the most responsive and smoothest flowing. If you use a fountain pen, it is important that you use only inks that are made for fountain pens. Waterproof inks contain shellac, which will ruin a fountain pen.

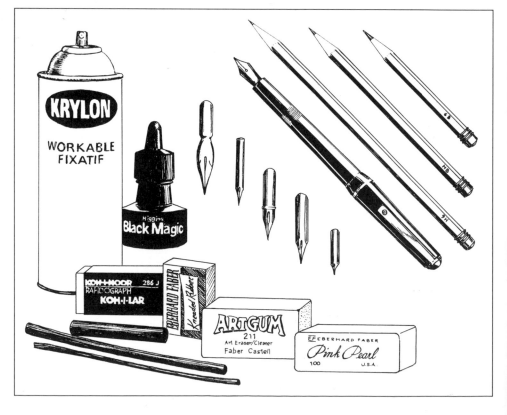

Virtually anything can be used to make a drawing. Pictured here are various pen nibs, drawing pencils, a fountain pen, white plastic eraser, gray kneaded eraser, art gum eraser, compressed charcoal, vine charcoal, ink, and workable fixative.

Basic Drawing Techniques

We now consider some basic techniques of drawing. First is the way you hold your drawing tool (pencil, pen, brush, charcoal, whatever). We all have experience writing with pencils and pens. Holding your drawing tool as you would for writing confines you to an area of about one to two inches in any direction, which is agreeable if the area you're drawing is no larger than this. But when you want to draw large shapes, don't hold the drawing tool this way, because your hand will block your view of part of the drawing. This can lead to proportion and placement errors. When drawing the eyes in a portrait, for example, I start with the eye on the left side of the paper first because I am right-handed. If I were to draw the eye on the right first, my hand would block my view of that eye while I drew the left one. I would then not be able to compare the eyes while drawing.

It is easiest to render the large shapes of your drawing first. When drawing these large areas (or when making large drawings) it is helpful to shift control from your fingertips to your wrist, shoulder, or, if you're standing, to your whole body. I suggest you start by holding the pencil from the eraser end. Or, hold it with your thumb and fingers in opposition, with the backs of your fingers against the paper. You can hold a stick of charcoal with the tips of your thumb and middle and index fingers. Another method is to position yourself far enough away from your paper to be able to use your body to influence the marks you make. These methods will keep your drawing light, loose, and focused on large shapes, and will eliminate or subdue the tendency to become involved in details too soon.

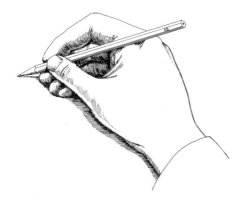

Holding the drawing tool this way is appropriate for small drawings or small areas of a drawing.

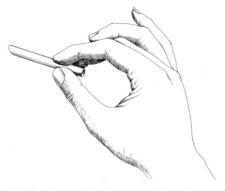

Holding the tool like this is good for making large, loose shapes in a drawing.

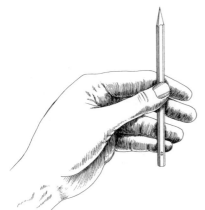

This method of holding the drawing tool shifts control from the fingers to the arm, which helps simplify the early stages of a drawing.

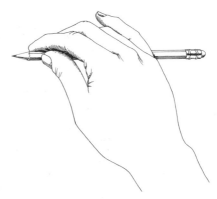

This way of holding the drawing tool also shifts control from the fingers to the arm.

There is nothing wrong with seeing detail or making a drawing that has a lot of detail in it. What is important is the sequence in which this happens. Start with the large, general shapes, followed by more specific shapes, then their lights and shadows, and then the details. At the end of your drawing, during the detail phase, it is appropriate to hold your pencil the way you would while writing, because now you are concerned with areas no larger than one or two inches in any direction. One of the most common errors students make is failing to follow this sequence. Remember: If you draw large, simple things first and small, complex things last, your drawing will develop easily and naturally.

It is helpful to draw on large paper; 18 x 24" (45.7 x 61 cm) is a convenient size. Your individual drawings need not be this large, but you don't want to run out of paper just as you get to an interesting part. No matter what size you choose, it is a good policy to use paper that is larger than your intended drawing. It is always possible to cut the paper afterward to the ideal size for the drawing. A drawing board slightly larger than your paper is also

useful. If the board has a noticeable texture, it is a good idea to place extra sheets of paper underneath your drawing while you work to prevent any unexpected bumps or irregularities in the board's surface from interfering with your drawing.

When you are drawing, the distance from your eye to the top of the paper should be equal to the distance from your eye to the bottom of the paper. If this is not the case, unwanted distortion may occur. If, for example, you are drawing with your paper flat on a table, the distance from your eye to the top of the paper is greater than it is to the bottom of the paper, and, as a result, the upper part of your drawing will tend to be larger in proportion to the lower part. To avoid this problem, rest your drawing board on the edge of the table and your lap for a better angle.

Resting your hand on the paper as you draw can cause problems—pencil, charcoal, or wet ink may smear, and the oil from your hands can affect the way paper takes ink. A simple solution is to place a clean sheet of paper under your hand while you work.

Start with large, simple shapes, followed by smaller, more specific shapes. Save the details until the end. When you work simple to complex, large to small, loose to tight, your drawing develops quickly and easily.

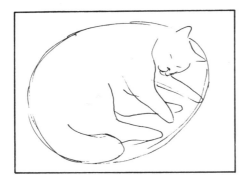
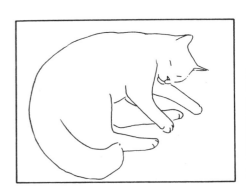
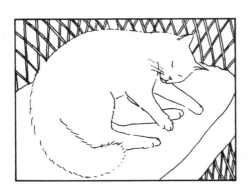
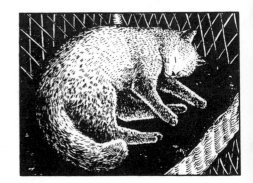

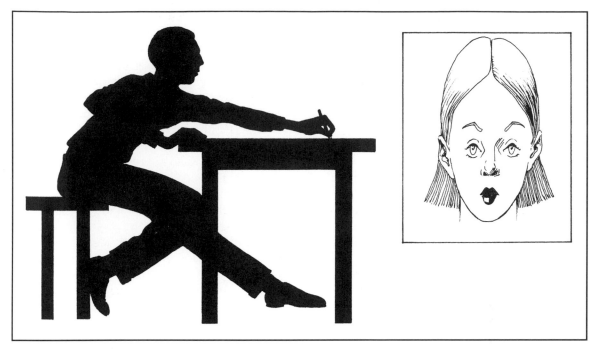

Distortions can result when the distance from your eye to the top of the page is not equal to the distance from your eye to the bottom of the page.

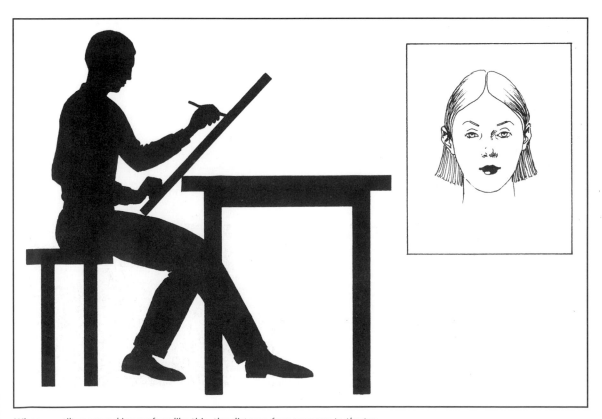

When you tilt your working surface like this, the distance from your eye to the top and bottom of the page is equal and there will be fewer distortions in your drawing.

Guidelines

When you begin a drawing, simple guidelines of some sort are helpful. These lines are usually very light and, where possible, are erased before the drawing is finished. If you are drawing an object that is somewhat circular in form, draw a light circle first and place the object within it. This is helpful in establishing the size of the object and its placement on the page. If the object has parallel sides, draw parallel guidelines and then place the object within them. If the object is symmetrical (meaning that one half is the mirror image of the other half), start with the center line as a guide. Variations in the outer

contours of symmetrical objects can be accurately drawn using guidelines that are perpendicular to the center line. For example, to draw a violin, start with the center line, then draw the parallel lines of the body and neck; next, draw lines perpendicular to the center line for accurate placement of the top, neck, shoulder, and waist of the violin. With these and any other necessary guidelines in place, you can then roughly draw in the violin. If corrections need to be made, this is when it is best to make them. Erase all unnecessary guidelines. Now refine and correct the drawing until you are satisfied.

Symmetrical objects can best be drawn by beginning with a center line. Loose, light lines are then placed at appropriate equal distances from the center line. Lines perpendicular to the center line limit the extent of these lines and accurately locate features on each side of the object.

Once the object is established, erase your guidelines and refine the drawing.

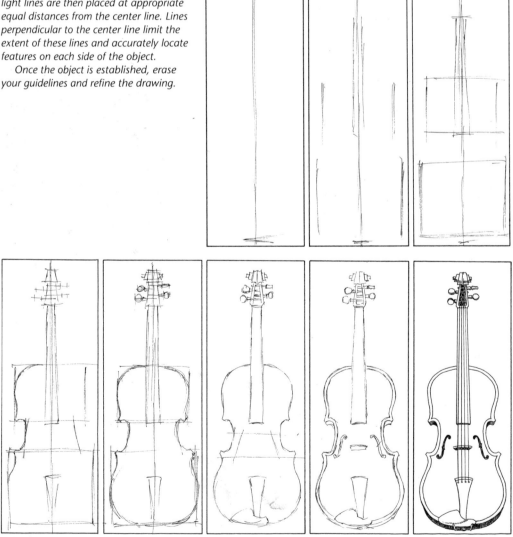

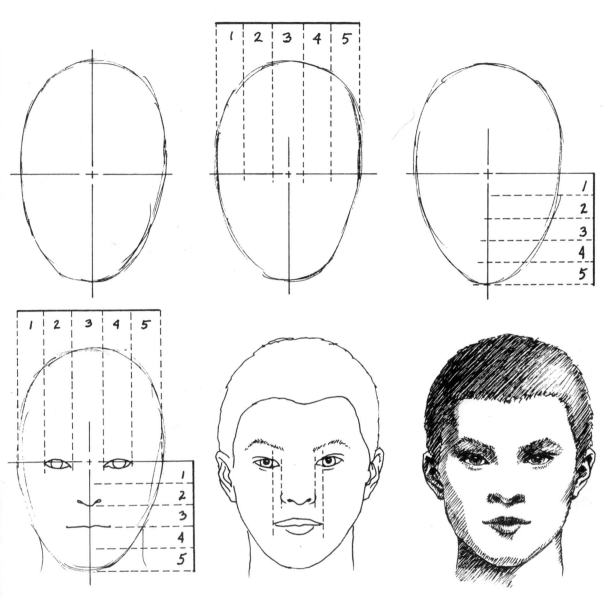

This simplified front view of a face starts with an egg shape, which is divided in half vertically and horizontally. To locate the eyes, divide the horizontal center line of the oval into five equal parts. The eyes fit in sections 2 and 4. To locate the length of the nose and the opening of the mouth, divide the lower half of the face into five parts. The bottom of the nose is usually located on the line between sections 2 and 3 of this division, the opening of the mouth on the line between sections 3 and 4. A nose is as wide as an eye; the width of the mouth is usually equal to the distance between the irises.

Angles and Proportions

Draw lightly and loosely at first. Find the placement on the page of what you are drawing and lightly rough in the general shapes. As you draw, measure constantly, always comparing the size of one thing or part to another. The edge of your pencil can be helpful in seeing angles. Remember to keep your drawing light and loose until you have everything where you want it. Now erase all wrong or unnecessary lines. This is your foundation. Next, make your commitments to specific lines or lights and shadows. Refine and correct this continually until you can think of nothing else to do. Then your drawing is done and you are ready to begin another. The more you draw, the better you will become at drawing.

To gauge the incline of an object accurately, hold your pencil parallel to it. Then, without changing the pencil's angle, move it to the drawing and make a mark on your paper. The mark should be parallel to the angle of your pencil and thus to the object you are drawing.

Finding the correct proportions of an object can sometimes be achieved by drawing a simpler view of the object and transferring those proportions to the view you want. Here, a simple top view is converted to a more complex, three-quarter view.

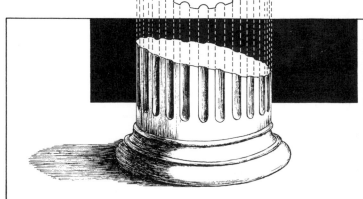

Some Basic Artistic Terms

Every profession has its own vocabulary. Before you go any further in this book, it will be helpful to familiarize yourself with the terms defined here.

Highlight: The side of an object receiving light and/or the actual brightest spot within a highlighted area.

Cast shadow: The shadow of an object in its environment.

Contrast: The relationship of light and dark values. Black juxtaposed with white is a high-contrast relationship; light gray next to dark gray is a lower contrast.

Ellipse: An oval; a circle seen at an angle.

Horizon line: The apparent junction of earth and sky, without regard to valleys, hills, mountains, or buildings.

Parallel: As applied to lines or surfaces, always the same distance from each other.

Picture plane: The actual surface of a drawing or painting.

Perpendicular: At a right, or 90°, angle to a given line or surface.

Proximity shadow: The shadow occurring at the point of contact or near-contact of two objects or surfaces.

Plane: Any flat surface, such as a wall, floor, or meadow.

Shadow: The absence of light on an object, as distinguished from a cast shadow.

Value: The relative lightness or darkness of a color.

Vanishing point: A point at which parallel lines receding into space appear to meet.

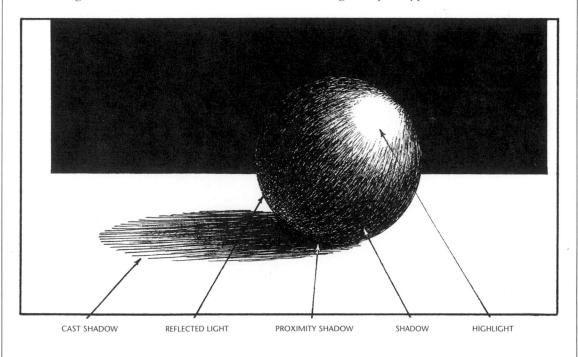

CAST SHADOW REFLECTED LIGHT PROXIMITY SHADOW SHADOW HIGHLIGHT

DRAWING THE BASIC SHAPES AND FORMS

The first step in drawing is always simplification. The world is a complex place.
A mistake many students make is trying to depict the world in all its
complexity. It is possible to put all the details of your perception in a drawing
or painting, but don't start with the details. Simplify first. All subjects are made
up of just a few basic shapes and forms. Learn to identify these basic
components, then begin your drawings with them.

*If you can draw the basic forms and see them in complex
objects, you will be better able to draw those objects.*

Silhouette and Line

The simplest depiction of an object is its silhouette, or outside contours. When I begin to draw an object, I usually start with its outside contours.

Choosing which silhouette to draw is important. The more information available in a drawing, the more likely the viewer's acceptance of the drawing's illusion of reality. If the silhouette is informative, the subsequent layers of light, shadow, and texture will be more understandable. With a subject such as a cow or a pitcher, it is the side view that provides the most information. Naturally we do not want to limit ourselves to side or profile views. But because the contour/silhouette is the first thing we see, it

helps to present significant information at this level.

Many drawings are restricted to just line, with no definition in values. In such drawings the silhouette is supplemented by internal lines that can describe overlapping forms, changes in direction (such as the corner of a cube), or changes in color and value (such as the spots on a leopard or the edges of a cast shadow). These lines are a code virtually everyone understands, but they do not create the illusion of reality; they are always abstract. Because most drawings and paintings start with outer contour and internal lines, even if only as a preliminary guide, it is appropriate to practice their use.

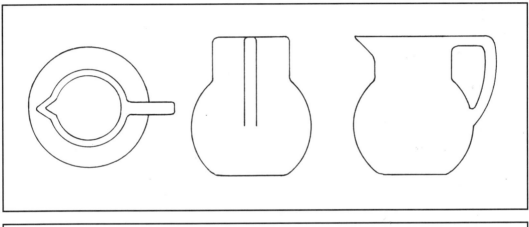

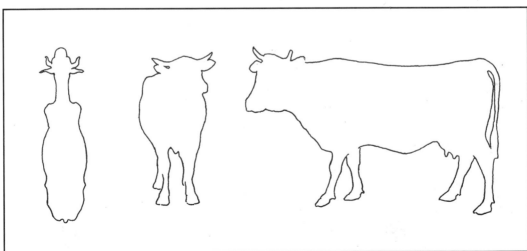

An object's silhouette is the first thing we see. The angle from which you view an object determines its silhouette, and some silhouettes give more information about the object than others. When you draw an object, your choice of an informative silhouette will greatly enhance your viewer's perception of the object. All of the images shown here inform us about the subjects, a pitcher and a cow, but in both examples, the side view tells us the most. The more descriptive a silhouette, the less we need to depend on color and value for comprehension.

Basic Two-Dimensional Shapes

At the two-dimensional level—the level of silhouettes—there are three basic shapes: the square, the circle, and the triangle. Simplified silhouettes of objects are created by combining variations of these three basic shapes.

All silhouettes can be constructed by combining parts of the three basic shapes: the square, circle, and equilateral triangle. Variations of these basic shapes include ovals, rectangles, and triangles with sides of different lengths.

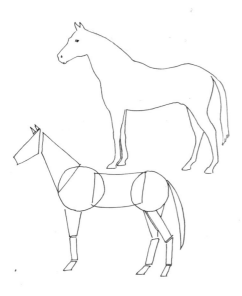

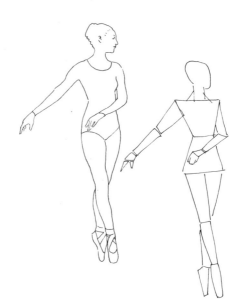

Even complex shapes like these are made by combining variations of the triangle, square, and circle.

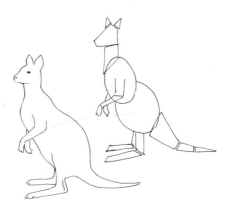

Basic Three-Dimensional Forms

At the three-dimensional level there are five basic forms: the sphere, the cone, the cylinder, the torus, and the cube. All three-dimensional objects can be constructed from the parts of these five forms. Things with flat surfaces and abrupt changes in surface plane, like the corners of a house or the hexagonal head of a bolt, relate to cubes. Curved planes, like the rounded arms of a sofa or the ripples of a flag, relate to cones or cylinders. Bumps, dents, and hills relate to spheres. A barbecue is composed of spheres and cylinders; a mailbox is a half-cylinder and a cube. The rounded circular rim of a cup relates to the torus, which is also the basic form of a coiled snake or chain links.

In studying the basic forms, you must also consider how they appear in the negative. For example, a crater is a negative sphere; a rut or a groove is a negative cylinder; an empty rectangular swimming pool is part of a negative cube.

The Sphere

The sphere is the easiest of the forms to draw because no matter what your angle of view, it is always drawn as a circle. Nearly pure examples of spherical forms are oranges, the moon, soccer balls, and bubbles.

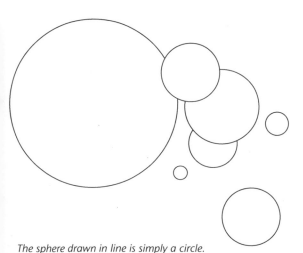

The sphere drawn in line is simply a circle.

The Cone

The cone is the next easiest to draw. It is simply a V with a circle between its ends. When seen at an angle, the circle is an ellipse. A line drawn from the center of the circular base to the point of the V is the cone's midline. If the cone's base is perpendicular to the midline, the cone's sides are drawn from the narrow ends of the ellipse. If not, the base of the cone will be seen as though cut at an angle. Nearly pure examples of cone forms are pencil points, Christmas trees, ships' masts, and witches' hats.

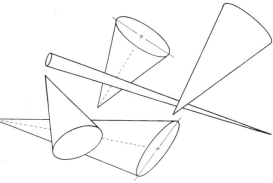

A cone is drawn as a triangle with an ellipse on one end. A line drawn from the middle of the ellipse to the point of the cone is called the midline. If a line drawn through the widest part of the ellipse is not perpendicular to the midline, the cone will not stand up straight.

Complex forms can be seen as combinations of the basic forms.

The Cylinder

The cylinder is drawn with parallel lines for the sides and circles between the parallel lines. (As with the cone, the circles become ellipses when seen at an angle.) If the top and bottom of the cylinder are perpendicular to its sides, the parallel lines are drawn from the narrow ends of the ellipses. A line from the center of one ellipse to the center of the other is the cylinder's midline. A line drawn through the widest part of the ellipse will be perpendicular to the midline of the cylinder. It is important to remember that although the top and bottom surfaces of a cylinder are parallel, they are not drawn as identical ellipses. The closer one of these surfaces is to your eye level (also known as the horizon line), the narrower the ellipse will appear; the farther from eye level, the rounder the ellipse will appear. (For more on this, see the chapter on elliptical perspective.) A foreshortened cylinder—one that is drawn narrower at one end to give the illusion of projection or extension into space—will appear to have sides that are not parallel, because they are drawn in perspective. In perspective, parallel lines appear to converge as they recede into space. Nearly pure examples of cylindrical forms are cans, broom handles, and curtain rods.

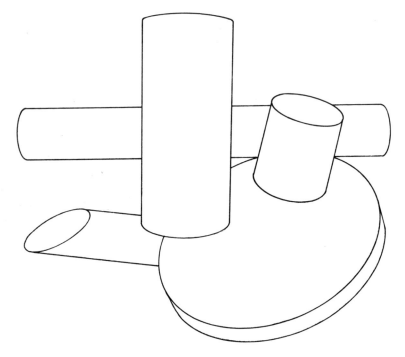

A cylinder is drawn as a pair of parallel lines with an ellipse at each end between the parallel lines. The ellipse nearer to your eye level will appear narrower than the one farther away from your eye level.

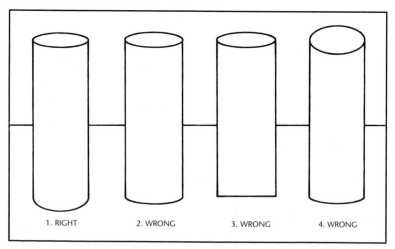

1. RIGHT 2. WRONG 3. WRONG 4. WRONG

In this illustration cylinder #1, at left, is drawn correctly, while the other three are wrong. In #2, the top and bottom ellipses are the same, but this cannot be the case because they are seen at different levels. Cylinder #3 is wrong because even though it sits on a flat surface, the bottom should not be drawn flat because the bottom of the form itself is curved. In cylinder #4, the top ellipse should be narrower because it is closer to our eye level than the bottom ellipse.

The Torus

The torus is a doughnut shape. Seen from above, it is just two circles, one within the other. From a three-quarter view, the middle of the external edge is the middle portion of an ellipse; the ends are portions of two small circles. The inside of the torus (the hole in the doughnut) is depicted by two arcs that form an ovoid (oval-like) shape with pointed ends. Nearly pure examples of a torus are a bagel, a coiled garden hose or snake, and a chain link.

A torus is drawn either as two ellipses, one within the other, or as an ellipse with two opposing arcs forming a pointed ellipse within. Seen from the side, a torus can be two parallel lines with a half-circle on either end.

The Cube

A cube is a box with six square sides. Pure examples of cubes are dice, filing cabinets, sheds, and washing machines. The cube is the most difficult form to draw correctly because it involves linear perspective. A more thorough explanation of linear perspective will be presented later in this book, but on the following pages you will find some basic concepts.

A cube is a six-sided form; each side is a flat square. This is the most difficult of the five basic forms to draw because it requires an understanding of linear perspective.

Perspective and the Cube

In linear perspective it is necessary to understand the concept of the *picture plane,* which is the actual two-dimensional surface of your paper (or canvas). The image on the paper is the depiction of what would be seen behind the paper's surface. If you were to trace the view out a window onto the glass, the glass would represent the picture plane.

The other concept to understand is *the horizon line,* which is, of course, the horizon; it is also called the eye level. Imagine a piece of cardboard with a rectangle cut out of it—a viewfinder. If you hold the viewfinder at the level of your eye, the horizon will be in the middle of the opening. If you lower the viewfinder, the horizon appears to move to the top of the opening. If you raise the viewfinder, the horizon appears to move to the bottom of the opening. Thus, in a drawing, when the horizon is high on the page, our focus is on things below our eye level (we are looking down). When the horizon is low on the page, our focus is on things above our eye level—over our head (we are looking up).

Imagine you are looking at a level box. If you can see the top of the box, it is below your eye level, so the horizon is above the box. If you can see the underside of the box, it is above your eye level, so the horizon is below the box.

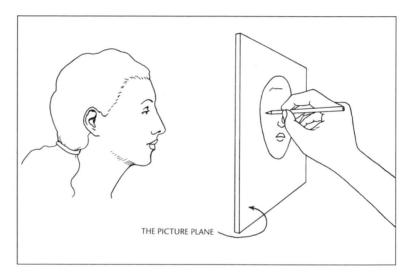

The picture plane is the actual surface upon which an image is created. The image appears to be behind the surface.

THE PICTURE PLANE

Understanding the horizon line is important in linear perspective. As the viewfinder, or frame, is raised, the horizon line appears to move to the bottom of the opening; as the frame is lowered, the horizon line appears to move to the top of the opening.

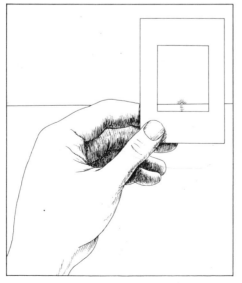

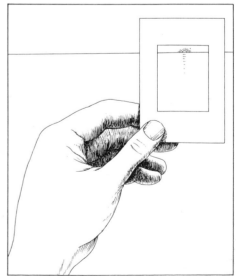

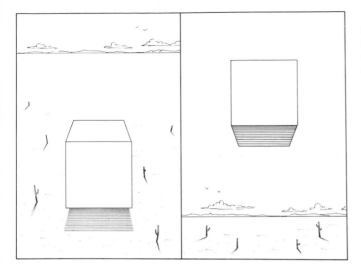

To give the impression of looking down, the horizon is placed high on the page. To give the impression of looking up, the horizon is placed low on the page.

One-Point Perspective and the Cube

The two most common and useful types of perspective are one-point and two-point perspective. The simplest demonstration of one-point perspective is to look down a straight road. We know the road to be the same width throughout its length, and yet as we look toward the horizon the road appears to get increasingly narrow, until it diminishes to a point on the horizon. This is called the *vanishing point* because it is where the road appears to vanish. On level ground, the vanishing point is always on the horizon. Place a cube in this road with the sides of the cube parallel to the sides of the road. The lines that describe the receding edges of the cube will converge at the same vanishing point that the road does. All receding parallel lines will share the same vanishing point.

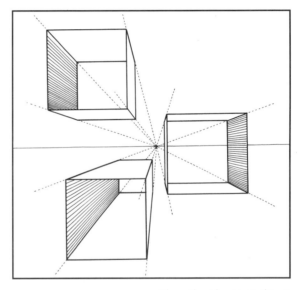

These three boxes are drawn in one-point perspective. The dotted lines indicate receding lines. All the receding lines meet at one point on the horizon line, indicating that they are parallel to one another.

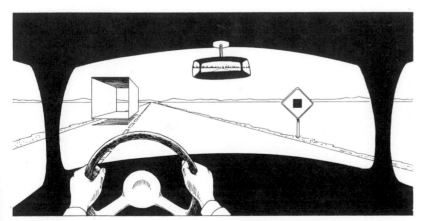

In one-point perspective, a straight flat road seems to get narrower in the distance, although we know that it doesn't. Imagine a box whose receding edges are parallel to those of the road. All of these edges "vanish" at the same point on the horizon.

One-point perspective is also used when you are depicting boxes or interiors that have faces or walls parallel to the picture plane. The horizontal and vertical lines on the faces parallel to the picture plane are drawn perpendicular to each other. All other receding edges of an object will converge at a point on the horizon line. In one-point perspective, the front and back of a cube are parallel to the picture plane. They are drawn as squares with perpendicular corners. The top, bottom, and sides of a cube in one-point perspective recede into space. The lines defining their receding edges will converge at a point somewhere behind the cube.

Remember: In one-point perspective, verticals and horizontals are perpendicular to each other on surfaces parallel to the picture plane.

When drawing a cube or box in one-point perspective, start with a perfect square or rectangle (all corners are 90° angles). This represents the side that is parallel to the picture plane. (The vanishing point is denoted as VP.)

To establish the top of the cube, draw lines from the top corners of the square to a point behind the cube on the horizon line.

The back of the cube is established (arbitrarily for now) by making a line parallel to the top of the front of the cube; the width of this line is defined by the perspective lines you drew from the cube's top front corners.

The receding lines of the top are now drawn in, connecting the back of the cube to the front.

We have now established a closed cube in one-point perspective.

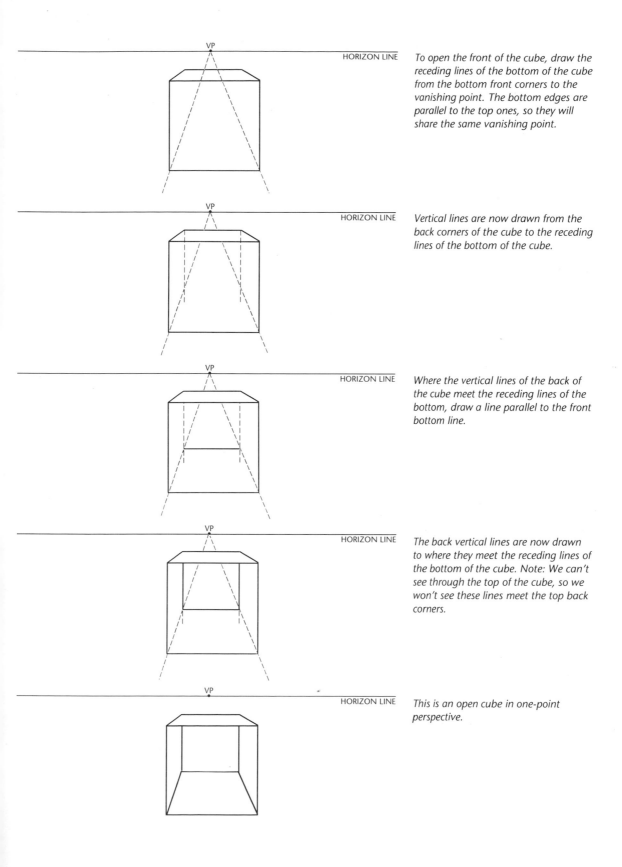

To open the front of the cube, draw the receding lines of the bottom of the cube from the bottom front corners to the vanishing point. The bottom edges are parallel to the top ones, so they will share the same vanishing point.

Vertical lines are now drawn from the back corners of the cube to the receding lines of the bottom of the cube.

Where the vertical lines of the back of the cube meet the receding lines of the bottom, draw a line parallel to the front bottom line.

The back vertical lines are now drawn to where they meet the receding lines of the bottom of the cube. Note: We can't see through the top of the cube, so we won't see these lines meet the top back corners.

This is an open cube in one-point perspective.

Two-Point Perspective and the Cube

Two-point perspective is used when only the vertical edges of the cube are parallel to the picture plane. This is unlike one-point perspective, in which whole sides of the cube are parallel to the picture plane.

With a cube in two-point perspective, only the verticals are truly parallel to each other. All other lines will appear to point to one of two vanishing points. If the cube is level, the vanishing points will be on the horizon. All lines parallel to each other will share the same vanishing point. The farther apart the two vanishing points are placed, the farther away from the object your viewpoint appears to be.

In one-point perspective, whole sides of the cube are parallel to the picture plane, as the example at near right shows. In two-point perspective, only the cube's vertical edges are parallel to the picture plane, as in the example at far right.

To draw a cube in two-point perspective, we start with the vertical edge nearest the picture plane. Vanishing points are placed (arbitrarily for now) on the left and right sides of the horizon line.

Lines from the top and bottom of the near edge are drawn to the vanishing point at right. This will establish the top and bottom edges of the right side of the cube.

Similar lines are drawn for the left side of the cube.

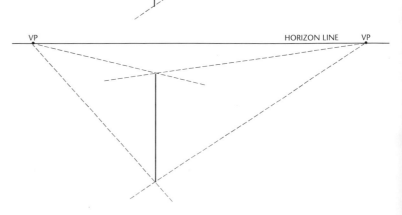

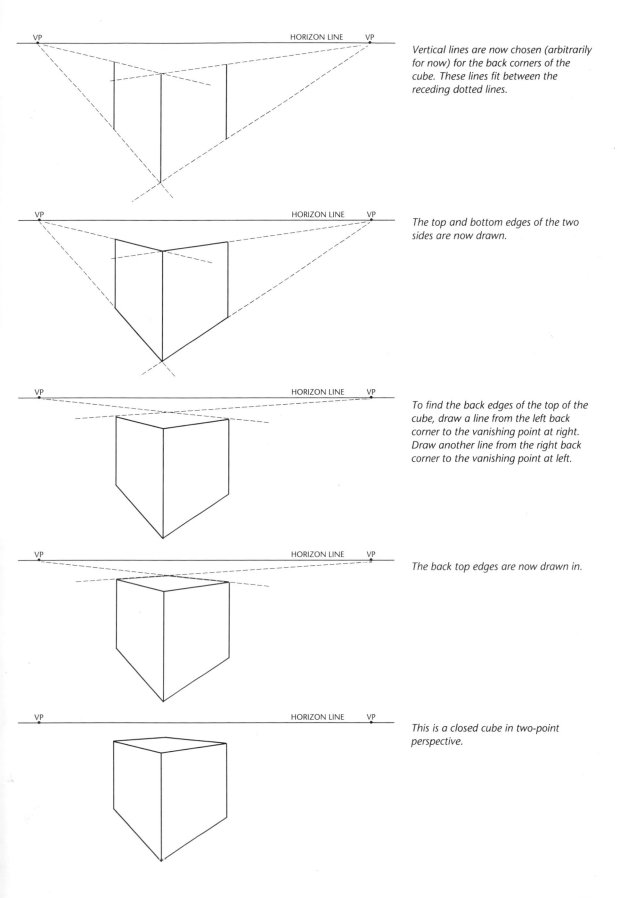

Vertical lines are now chosen (arbitrarily for now) for the back corners of the cube. These lines fit between the receding dotted lines.

The top and bottom edges of the two sides are now drawn.

To find the back edges of the top of the cube, draw a line from the left back corner to the vanishing point at right. Draw another line from the right back corner to the vanishing point at left.

The back top edges are now drawn in.

This is a closed cube in two-point perspective.

To depict an open cube in two-point perspective, draw a line from the vanishing point at left to the right front bottom corner.

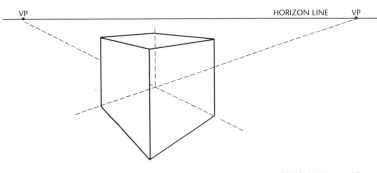

To establish the depth of the cube, draw a line from the vanishing point at right to the back left bottom corner. Then draw a vertical line from the top back corner to where the lines from the vanishing points cross.

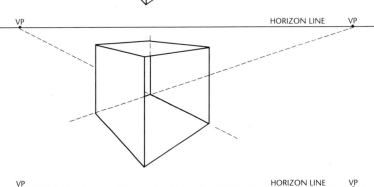

Draw the lines where we would see them if only the right side of the box were open.

This is an open cube in two-point perspective.

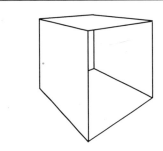

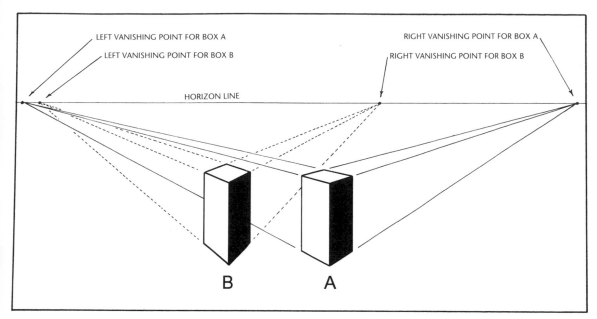

LEFT VANISHING POINT FOR BOX A

LEFT VANISHING POINT FOR BOX B

RIGHT VANISHING POINT FOR BOX A

RIGHT VANISHING POINT FOR BOX B

HORIZON LINE

B A

In two-point perspective, vanishing points are widely separated when the object is far from our point of view.

Exercises

Reading about these concepts is not enough. You must teach your hand what your mind knows.

Draw the silhouettes of the basic forms from many different angles. I recommend drawing them on gray construction paper. Cut out the silhouettes, turn them over so you don't see your drawing lines, and determine which of the views you prefer and which best describe the forms.

As a further exercise, find several objects that are combinations of the basic forms, such as an ice cream cone, which is made of a half-sphere and a cone, or a Band-Aid box, which is a cube with cylindrical corners. Draw many views of these combined forms on the gray construction paper, cut them out, turn them over, and determine which you prefer and which give the most information.

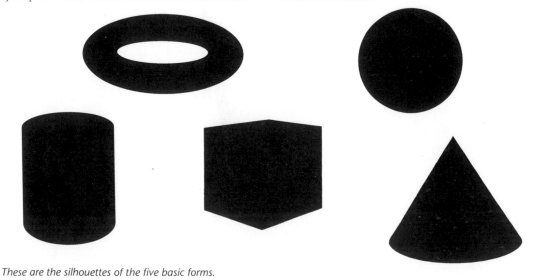

These are the silhouettes of the five basic forms.

VALUE AND THE ILLUSION OF FORM

We now look at how value—the relative lightness or darkness of a color—defines the basic forms. Value shapes are, in fact, stronger indicators of form than outside contours. Since childhood we have recognized objects by the characteristic light and shadow shapes and value patterns that describe them. However, we may not realize how we came to have this knowledge. Increasing our awareness of how value defines form will greatly enhance our ability to create the convincing illusion of three dimensions in the objects we draw and paint.

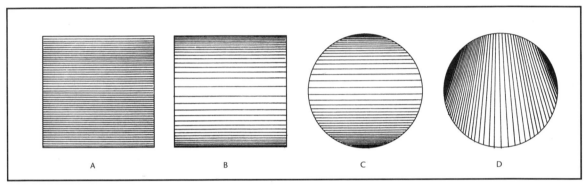

A B C D

Value patterns are stronger indicators of form than contours. Here, the value pattern on A describes the square as the face of a cube parallel to the picture plane. The value patterns on square B and circle C describe cylinders, while the pattern on circle D actually describes part of a cone.

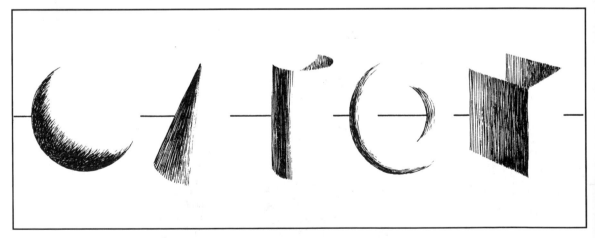

Notice how the dark value shapes alone can define the basic forms.

Defining the Basic Forms with Value

Presented here are the rules that govern how value patterns define the basic forms in their ideal state. It is possible to find on these forms light and shadow shapes that do not fit the rules—shapes created when the light source is at an unusual angle, for example. It is not necessarily wrong to include these "other" shapes in your drawings, but they will not enhance, and may actually confuse, your viewer's recognition of a given form, as well as interfere with the illusion of three-dimensionality.

The Cube

A cube is made up of flat areas called planes. When a cube's plane is parallel to the picture plane, it is depicted as a single tone. A cube in one-point perspective will have its front surface, or plane, depicted as a single tone because the front is parallel to the picture plane. When a cube's plane is not parallel to the picture plane, it is depicted as a blend, a gradual transition from a lighter to a darker value.

Strong contrast between an object and its surroundings (including adjacent forms) makes the object appear to advance; weak contrast between these elements makes the object appear to recede. A cube's plane appears to recede in space when the contrast between its value and that of its surroundings is greatest in the foreground and least in the background. Thus, when drawing a cube's plane against a light background, you would make the blend darkest on the part of the plane that's closest to the foreground so it will seem to advance, and lighten the blend progressively as the plane recedes in space toward the light background.

A cube with no side parallel to the picture plane is made up of various blends. How these blends are arranged will determine whether we are looking at the outside or the inside of the cube. If the light portion of a blend on one plane meets the dark portion of a blend on an adjoining plane, a strong contrast results, creating the impression of an edge that comes forward. Conversely, a low contrast between the values of blends meeting at the juncture of two planes creates the impression of an inside or receding corner. Imagine an open box. The corner nearest the picture plane is composed of two adjacent planes that contrast more with each other than do the two planes that meet to form the inside far corner of the same box.

Remember these points:

- All flat planes are treated the same as the sides of a cube.

- A clearly defined border between the values of two flat planes implies a sharp edge. As the border between these two values becomes more gradual, or blended, the edge appears rounded; the wider the blend the more rounded the edge. The rounded edge of a cube is actually a portion of a cylinder.

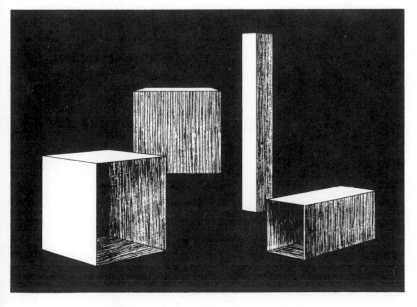

Cubes are made of flat areas called planes. A plane that is parallel to the picture plane is depicted as a single value. A plane that is not parallel to the picture plane is depicted with a blend, a gradual transition from one value to another.

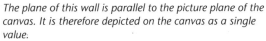

The plane of this wall is parallel to the picture plane of the canvas. It is therefore depicted on the canvas as a single value.

The plane of the cheese is not parallel to the picture plane of the canvas in this illustration. It is therefore depicted on the canvas as a blend from one value to another.

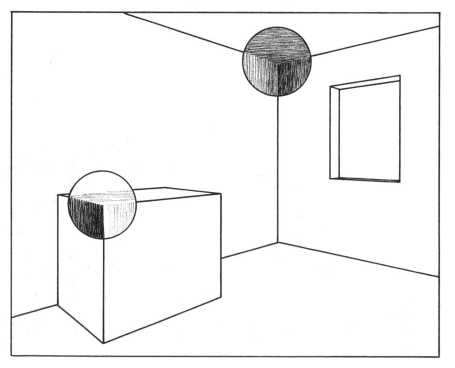

The inside corner of the room appears to recede because where the planes (walls) meet, the blends that describe them are in low contrast. The near corner of the box advances because the blends of its planes meet in high contrast.

The Cylinder

A solid cylinder has a flat top and bottom, which are depicted as flat planes, just as the sides of a cube are. The curved part of the cylinder is depicted with a blend of values rendered as parallel stripes. As long as values are in parallel stripes, the form described is cylindrical.

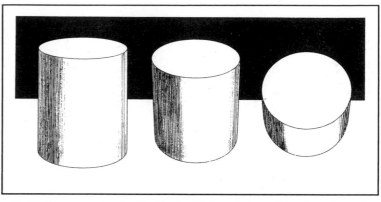

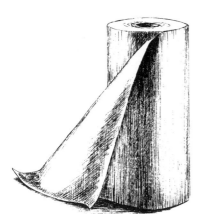

Cylindrical forms are described by blends of light to dark parallel stripes. The angle from which you view a cylinder determines the shape of its top; from overhead this shape is a circle, while at other angles it appears to be an ellipse (for more on this, see the chapter on elliptical perspective).

A roll of paper is a cylindrical shape; its light and shadow shapes are blends of parallel stripes. (The loose paper is a cone.)

The Cone

The flat bottom face of a solid cone is a plane and is therefore depicted with a blend, as on a cube. The top of the cone is created with adjacent triangular blends of different values radiating from the apex. There is more contrast between the light and dark areas on the narrow part of the cone than on the wide part.

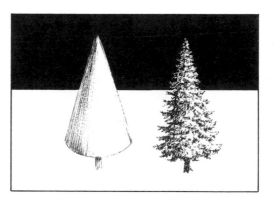

A fir tree is cone-shaped. Look for triangular areas of light and dark.

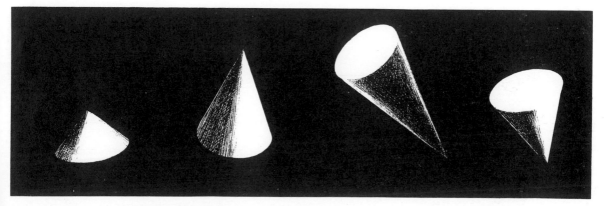

Adjacent triangular blends radiating from a point describe cones.

The Sphere

A sphere is made of two shapes, a crescent and an oval. Depending on the angle of the light hitting it, the sphere is a combination of light crescent (its lit side) and dark oval, or dark crescent (its shadow side) and light oval. A sphere illuminated so its light and dark sides are evenly divided, and thus represented as two half-circles (one light, one dark), will look only somewhat three-dimensional. When I have to draw such spheres, I usually adjust the shadow and light to form subtle crescents and ovals, because I know that this will enhance the illusion of three-dimensional form.

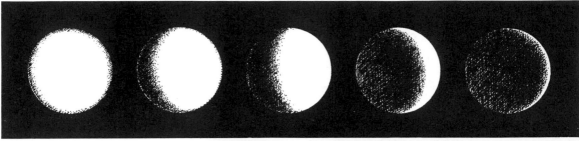

On spheres, the light and shadow shapes are crescents and ovals (actually ovoids, or oval-like shapes).

An oak tree resembles a half-sphere. Look for a partial crescent or oval on its shadow side.

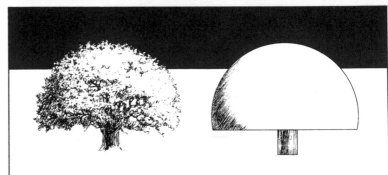

The Torus

The torus is a combination of the cylinder and the sphere. The middle portions of a torus are curved cylinders. Where the cylinder curves back on itself, the torus looks like portions of a sphere. As defined by value shapes, the middle of the torus is seen as curving parallel stripes and the returning curves are seen as portions of crescents or ovals.

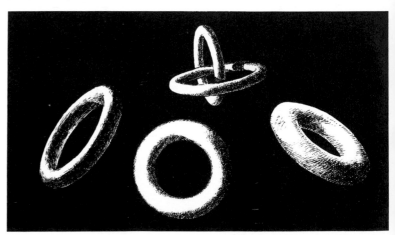

The torus combines the light and shadow shapes of spheres and cylinders. The middle portions of a torus are usually defined by curving parallel stripes. The returning curves are portions of crescents or ovals.

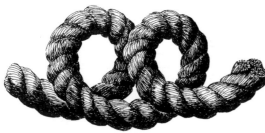

This piece of rope is a torus. Look for the distinguishing light and shadow shapes of its form.

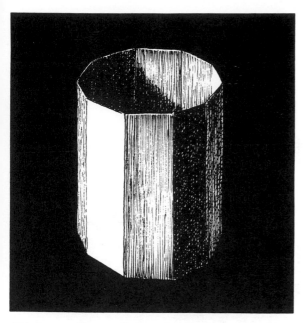

In observing forms, take note of the following:

- When we see a single value, we are seeing a plane that is parallel to the picture plane.

- When we see values as an even blend, we are seeing a plane that is not parallel to the picture plane.

- When we see values as blends of parallel stripes, we are seeing cylindrical forms.

- When we see values as blends of adjacent triangles, we are seeing conical shapes. And we expect to see a little more contrast between darks and lights at the point than at the wide part.

- When we see values forming crescents and ovals, we are seeing spherical shapes.

This form combines a cylinder and a cube. Notice how with each change in plane there is a change in value.

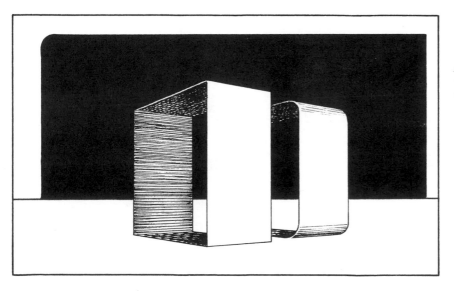

The object on the right combines a cylinder and a cube. Notice the treatment of its corners and how they differ from those of the object at left.

Negative Forms

All of the basic forms have negatives of themselves. For example, the inside of a soup bowl is a negative sphere; the inside of an open box is a negative cube; a well is a negative vertical cylinder. The same rules about value shapes that apply to positive forms apply to negative forms.

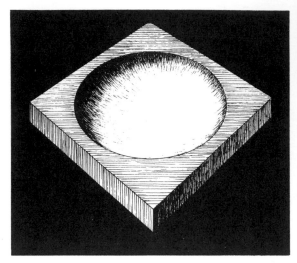

The negative form of a sphere is a crater, in which we see crescents and ovals of light and dark just as we do in the positive form.

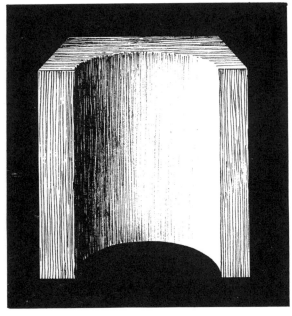

The negative cylinder is depicted with light to dark blends of parallel stripes.

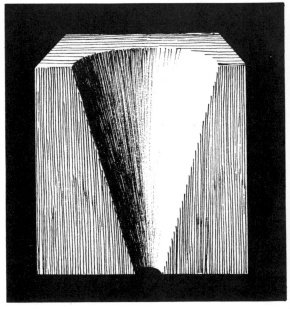

The negative cone shape is depicted using adjacent triangular blends.

Exercises

Return to the shapes you cut from the gray paper in the previous exercises.

Cut from black and white paper the light and shadow shapes that will further define the forms: triangle shapes for the cone, parallel stripes for the cylinder, crescents and ovals for the sphere, four-sided shapes for the sides and top of the cube. (If you can find blended paper, use it for the cube; otherwise, just use a different value of gray for each side.)

Now glue the various pieces together to create the impression of three-dimensional forms.

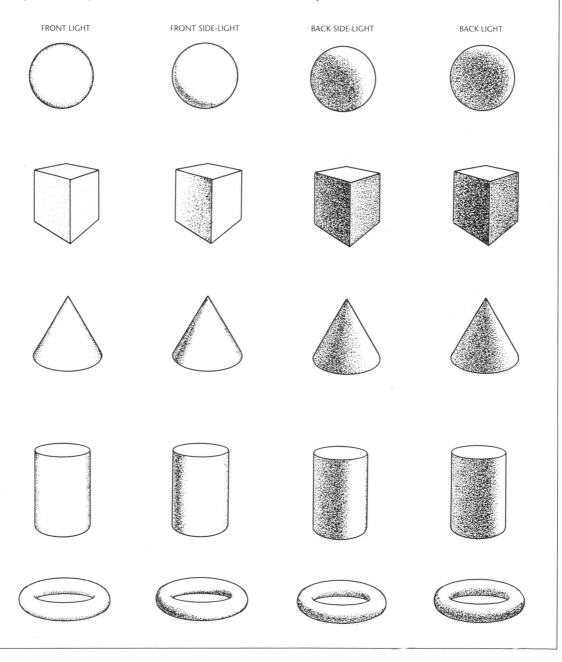

FRONT LIGHT FRONT SIDE-LIGHT BACK SIDE-LIGHT BACK LIGHT

CONTRAST

Contrast describes the relationship between light and dark values. To understand contrast, make a value scale. Draw ten squares, making the first one white and the last one black. Then create a range of eight grays between them, progressing from light to dark. It is the distance between values on such a scale by which we measure degrees of contrast. The farther apart two values are on the scale, the stronger the contrast between them. Black is farthest from white; thus, when juxtaposed, these two extremes create the greatest possible value contrast. Less contrast exists between a light gray and a dark gray, and still less between a dark gray and black, which are very close to each other on the scale. Contrasting values placed side by side will accentuate each other; lights will appear lighter and darks will appear darker.

As you will discover, a skillful use of contrast can help you establish the illusion of distance and define the quality of light in your drawings.

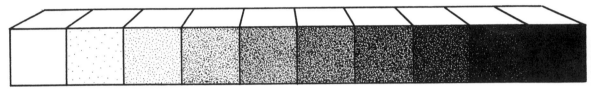

This is a value scale. Contrast is the relationship of two or more values on the value scale.

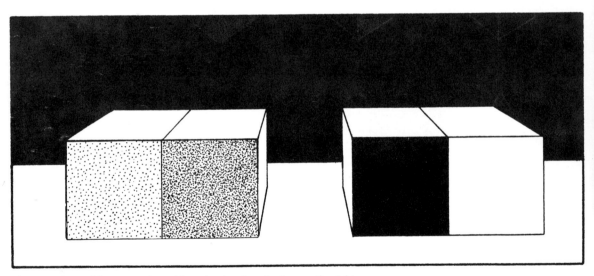

The two cubes at left contrast less with each other than the two on the right.

Creating the Illusion of Distance and Depth

One of the innate clues we use in our perception of distances is this: The greatest degree of contrast will be in the foreground, the least in the distance. Imagine two identical white horses standing in a field at midday, each at a different distance from you. The light and dark areas on the near horse will appear slightly more pronounced than on the distant horse. Likewise, the cast shadow of the near horse will appear darker than that of the far horse. This type of contrast relationship establishes distance even without the additional clues of scale, perspective, or placement in the environment.

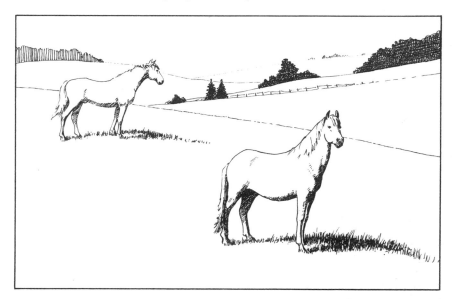

The shadows and cast shadows of the horse in the foreground are darker than those of the background horse. This contrast relationship indicates each horse's distance from the picture plane.

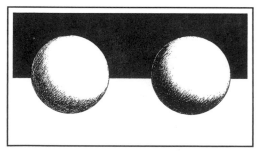

These two spheres are the same size and have the same placement in space. The sphere on the right appears closer to the viewer because it contrasts more with the white background than the sphere at left.

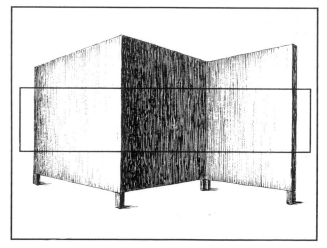

The corner of the screen that comes forward does so because the contrast between the planes that form it is greater than that between the planes of the corner that recedes. If we isolate the middle of the screen so that we see no perspective, these corners still advance and recede.

When you are dealing with vast areas, it is easy to see the reduction of contrast between the light and dark sides of objects. When you are viewing distant mountains, you may see so little contrast between the light and shadow on them that they can appear as a single-value silhouette. Contrast is also important in distinguishing small distances, such as in a portrait, where a subtle contrast of light and shadow between the tip of the nose and the planes of the cheeks will define the distance between those features.

Strong value contrast in the foreground of your drawing is very useful in the depiction of fore-shortened objects. It works this way: When you draw an object on a flat surface like paper, you are limited to working in two dimensions, height and width. To express depth, you foreshorten the object—shorten the parts that come forward—thus creating the illusion of projection or extension in space. Contrast is used to enhance this illusion; an object seems to come forward in space when the contrast between light and shadow is strong, and

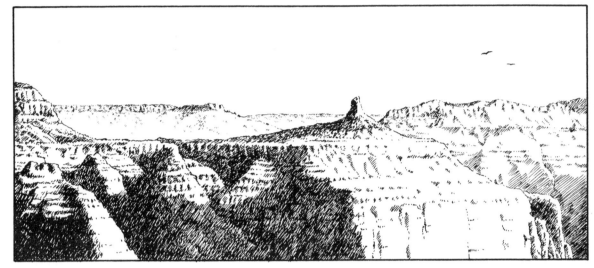

The contrast between light and shadow is stronger on the rock formations in the foreground of the picture plane than on those that recede into the background.

The light and dark contrasts on the hand, and between the hand and the background, are stronger than those on the face. This shows how, even in comparatively shallow space, contrast differences are used to establish spatial relationships.

seems to recede when this contrast is weak.

The value of the background in your composition can enhance the illusion of depth. For example, depicting a light object against a dark background (or a dark object against a light background) sets up a strong contrast that makes the object appear closer to the viewer. And, because strong contrast naturally attracts the eye, it is an important tool when you want to draw the viewer's attention to a particular area of a composition.

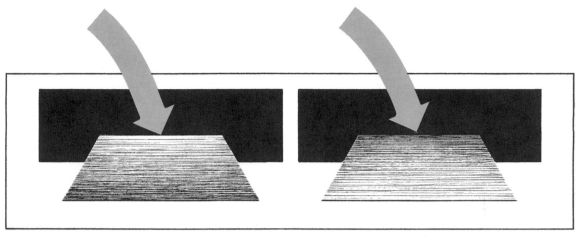

Although the perspective implies two receding planes, only the one on the right appears to recede. The example at left appears to stand upright because the contrast between the shape's light top and the dark background is equal to the contrast between the shape's dark bottom and the light background.

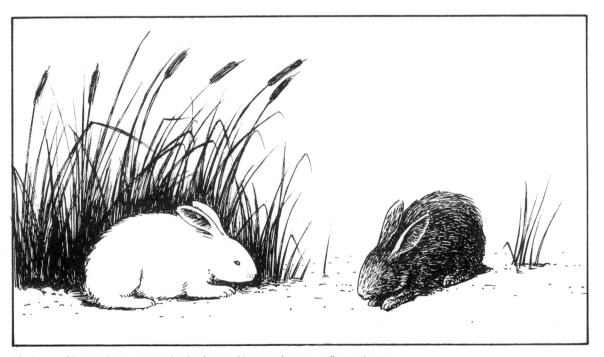

Placing a subject against a contrasting background is a good way to call attention to it. If these rabbits were reversed in compositional placement, both would disappear.

Reflected Light

Light can strike an object from many different directions, but it is the strongest light—the primary light source—that best defines an object. Thus, to firmly establish form in a drawing, emphasize the primary light source, then hint at other light sources.

The most common and, when you are depicting form, useful of the other light sources is the light reflected back to an object from nearby surfaces. Light from the primary source that does not fall on an object continues past it into the environment, and some of this light is bounced back as reflected light. Most convex objects will have some reflected light within their shadowed side. The lighter the area reflecting the light, the greater the amount of reflected light on the object.

It would seem logical to assume that the part of an object farthest from the light source would be the darkest. But this is not the case. Because of reflected light, the darkest dark of a convex object is usually within the object, not on its edge.

It would also seem logical that the lightest part of an object would be on the side nearest the light, but this is not so. The light striking the side of an object nearest the light source is bounced back toward the light source. The light on the lightest part we see must bounce off a surface somewhere between the angle of the light source and the angle of our vision. Because of the path light must follow to get to our eye, the brightest part of a lit object is not its edge.

We have said that the lightest light and the darkest dark rarely appear on the edge of an object; it follows, then, that on a convex object, the value contrast is stronger on the middle of the form than at its edges. Thus, the middle of the form appears to come forward, while its edges appear to recede. As contrast between light and shadow is increased, so is the illusion of three dimensions.

Reflected light comes in the same shapes on the basic forms as other lights and shadows; on a cone, for example, it appears as a triangle.

Reflected light bounces back from the environment and lights the shadow side of objects. Reflected light is never as strong as the primary light.

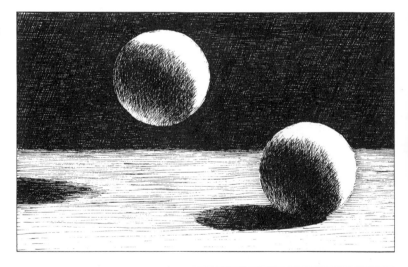

The lighter the reflecting surface, the greater the amount of light it will reflect.

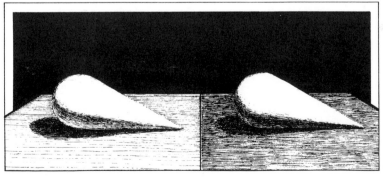

Distinguishing Concave from Convex

Imagine two blocks of wood, each six inches square. On top of one is a wooden sphere five inches in diameter. The top of the other has a five-inch-wide, half-spherical hole carved into it. The sphere is a *convex* form; the half-spherical hole is a *concave* form. Imagine you are looking down at the top of these two blocks and are asked to draw them. In both drawings the contours would look the same, a square with a circle inside. What value clues would you use to distinguish these two objects? How do we distinguish what goes in (concave) from what goes out (convex)?

Convex objects receive reflected light; thus, the darkest part of a shadow on a convex object is not on the object's edge. Concave objects do not receive reflected light; thus, the darkest part of a shadow on a concave form is on its edge. In drawing the convex wooden sphere, include some reflected light on the side opposite the one lit by the primary light source. This will place the darkest part of the shadow closer to the middle of the object. The brighter the reflected light, the nearer to the middle of the form the darkest dark will be. In drawing the concave half-sphere, place the darkest dark on the edge nearest the primary light source. The darkest shadows on concave forms are on the side nearest the light.

It is important to note that concave objects can appear, at first glance, as either convex or concave, but that convex objects only appear convex.

We distinguish between concave and convex forms through reflected light. Concave forms receive no reflected light; convex forms do. The darkest dark on a concave form is on the edge closest to the light. Because of reflected light, which appears on the side opposite the light, the darkest dark on a convex form will not be on the edge.

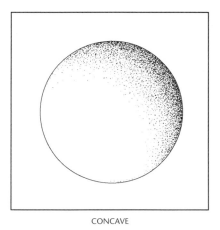

CONCAVE

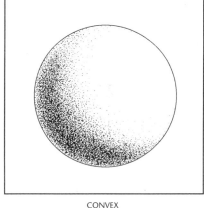

CONVEX

One of these pictures seems to describe a concave form, the other a convex form. Turn the page upside down and see what happens. Concave forms at first glance can appear either convex or concave. Both of these examples are concave.

When depicting convex objects in almost purely frontal light or back light (light sources that least define an object's three-dimensionality), it is useful to include some trace of reflected light in order to enhance the illusion of convexity.

Concave forms are also identified by value shapes. In cone-shaped holes, shadow and light will take the shape of triangles; inside cylinders, they will appear as stripes; in concave spheres, they will appear as portions of crescents or ovals; and inside cubes, they will appear as gradual blends.

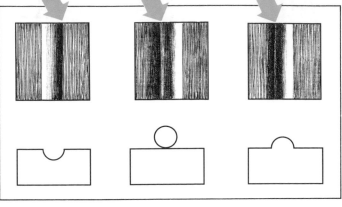

Here we compare concave and convex forms. What are the important differences?

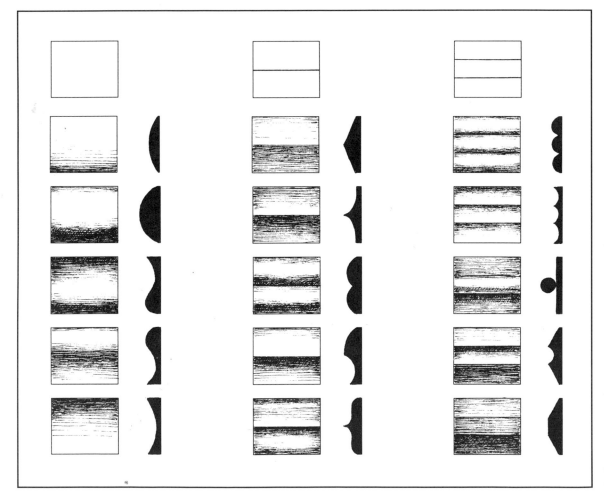

At the top of each column is a line drawing that can imply any of the forms shown below it. Value has been used to define the many three-dimensional possibilities. To the right of each form is its profile in silhouette.

Value Contrast and the Quality of Light

There are two basic types of light: *direct* and *diffused*. Direct light is what we see outdoors on a sunny day or emanating from a strong spotlight. Diffused light is what we see outdoors on a foggy or overcast day, or indoors where there are multiple light sources or where the light is bounced off another surface, like the ceiling.

Direct light gives the best definition of texture and three-dimensional form, whereas diffused light offers the least definition. (Strong direct frontal or back lighting, however, can cause silhouetting—flattening of form.) The area of transition from light to shadow on an object in direct light is short; in diffused light the transition from light to shadow is long.

Direct light yields distinct, sharply focused, dark cast shadows; the darkest cast shadows result from the strongest light. Diffused light yields cast shadows that are indistinct, have their edges out of focus, and are lighter than those caused by direct light. If the light is sufficiently diffused, the only cast shadow is a *proximity shadow*, one that results when two objects touch.

A picture whose values are all in the middle to dark range looks as if it is in a shadow. If the values are all in the middle to light range, the picture seems to be covered with a haze or mist. Using a wide range of values in a picture, including extremes of light and dark, creates a feeling of strong light and clear air.

The two basic types of light are direct *and* diffused *light. Direct light, such as sunlight, causes strong contrasts and well-defined cast shadows.*

Diffused light, as on a rainy day, causes low contrasts and vaguely defined cast shadows.

In direct light, the texture of an object appears more pronounced and is confined to a relatively small area. In diffused light, texture is subtler and can be seen over a wider area.

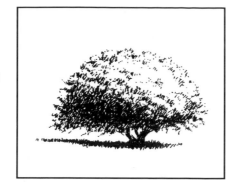 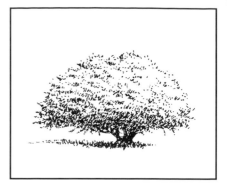

In extremely diffused light, the only cast shadows are proximity shadows—the shadows we see when two objects touch.

Light is everywhere, even in cast shadows, where, although greatly diminished, it still reveals form. Objects located within cast shadows are in diffused light.

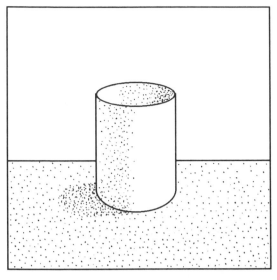

Some points to remember:

• Objects located within cast shadows are always lit with diffused light.

• The effects of direct light are:
 – high contrast
 – well-defined transitions between light and shadow areas
 – pronounced textures
 – clearly defined cast shadows

• The effects of diffused light are:
 – low contrast
 – subtle transitions between light and shadow areas
 – muted textures
 – vaguely defined cast shadows

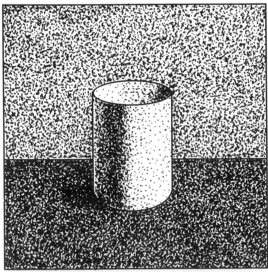

Exercises

Draw an even tone to depict a plane parallel to the picture plane. Then draw a blend describing a plane that is not parallel to the picture plane.

Draw, in succession, a blend that describes a cylinder; a cone; and a sphere.

Using line only, draw the five basic forms as they would appear when concave and when convex. Next, put the appropriate shadow and light shapes on these drawings. Include reflected light on the convex forms. Arrange the contrast so that some forms appear to advance toward the foreground and others recede into the background.

Again using only line, draw two squares with a circle inside each. Then draw the lights and darks so that one circle looks like a concave form and the other convex.

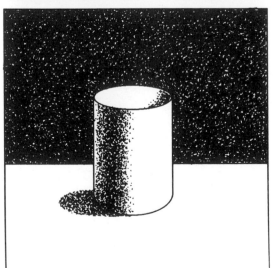

When a composition has only middle and light values overall, a haze or mist seems to cover the picture. When only middle to dark values are used, the picture seems to be in a cast shadow. When a full range of values that includes extremes of dark and light is used, the picture seems to be in clear air and strong light.

CAST SHADOWS

For purposes of clarity, a distinction is made between the shadowed part of an object (which we will refer to simply as *shadow*) and the shadow the object creates on another surface (its *cast shadow*). Each has distinct functions, and knowing them can help you create the illusion of three-dimensional form in your drawings.

A shadow *is defined as the part of an object not receiving light. A* cast shadow *is the shadow an object casts on another surface by blocking the light.*

Cast Shadows and Three-Dimensional Form

In your efforts to convey three-dimensional form in your drawings, it is helpful to remember the following points:

• Shadows serve to define the internal contours of an object.

• Cast shadows serve to orient an object in its environment; they also help to describe that environment.

For example, a cast shadow that is not connected to the object that casts it indicates that the object is floating in the air. A cast shadow that duplicates the silhouette of the object indicates that the surface receiving the cast shadow is parallel to the picture plane and the light source is near the observer. The curves in the cast shadow of a straight object help describe the curved surface receiving the shadow.

The characteristics that distinguish cast shadows from stains, wet spots, and other variations in value are these:

• A cast shadow is darkest near the object that casts it and lightest at the point farthest from that object.

• A cast shadow's edge is in sharpest focus near the object casting the shadow and becomes softer farther away from that object.

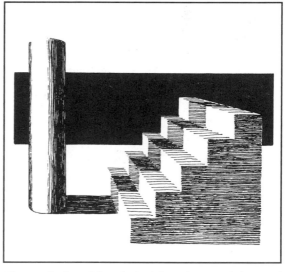

The cast shadow of the cylinder defines the ground plane and helps to define the steps.

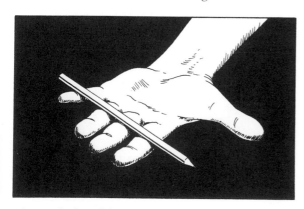

The cast shadow of the pencil helps define the contours of the fingers.

In the drawing at near right the separation between the bird and its cast shadow shows that the bird is off the ground. In the drawing at far right the bird's cast shadow tells us that there is a wall close to the bird and that the light source is frontal.

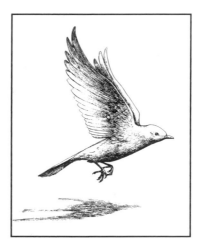

49

The edge of the seal's cast shadow describes the gravel shore.

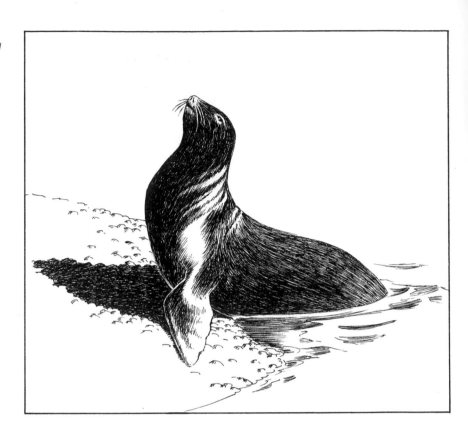

The cast shadow of the beehive implies the texture of the grass, even where grass has not been drawn.

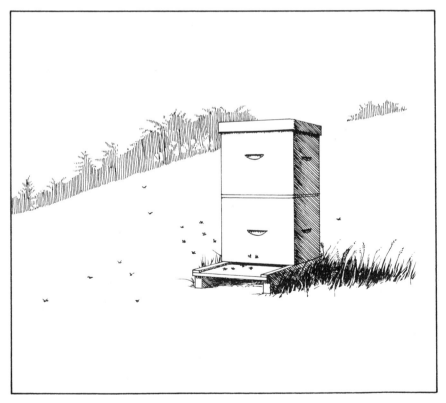

Length and Direction of Cast Shadows

To calculate the length and direction of a cast shadow, follow the steps described in the sequences of illustrations shown below and on page 53. Further examples of how cast shadows work show you what happens in a variety of lighting and compositional situations. Knowing how to do this is useful when you are drawing from your imagination or when cast shadows are obscured by objects you don't want to include in your picture.

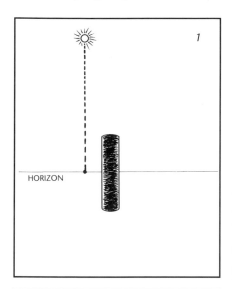

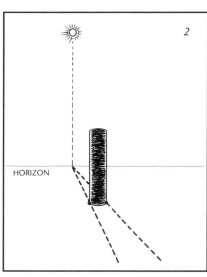

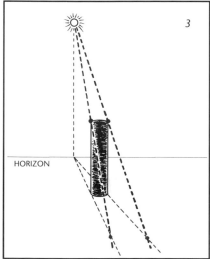

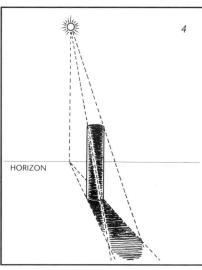

1. To calculate length and direction of a cast shadow, first locate the light source, and then locate the point directly beneath the light on the surface (plane) receiving the cast shadow. Make a mark at the imagined point of contact. (When the sun is close to the horizon, the horizon is the point of contact.)

2. From this mark, draw lines through the outer edges of the part of the object touching the ground. This will give us the direction and width of the cast shadow. (Treat the object as though it were transparent to locate the edges on the back side.)

3. Draw lines that start from the light source, touch the top of the object, and continue until they intersect with the lines that define the edges of the cast shadow. Where these lines meet marks the length of the cast shadow.

4. Place the cast shadow on the ground within these lines.

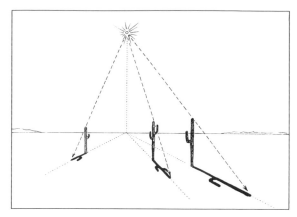

The cast shadow of each
object in a composition is
calculated separately.

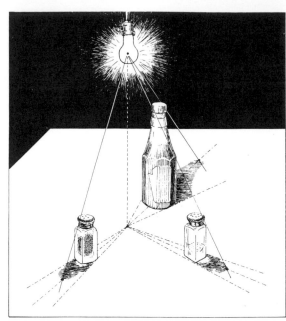

If the light source is
central to a group of
objects, all the cast
shadows will radiate
from that central point.

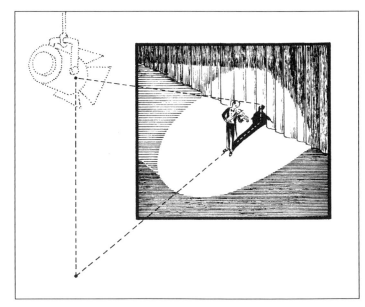

When the light source is
off the page, its position
must be imagined to
calculate the length and
direction of cast shadows
within the picture.

Notice how a cast shadow can be
calculated even when the surface
receiving it changes direction.

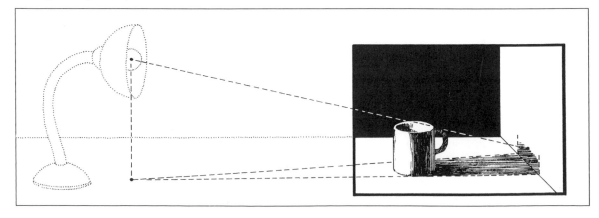

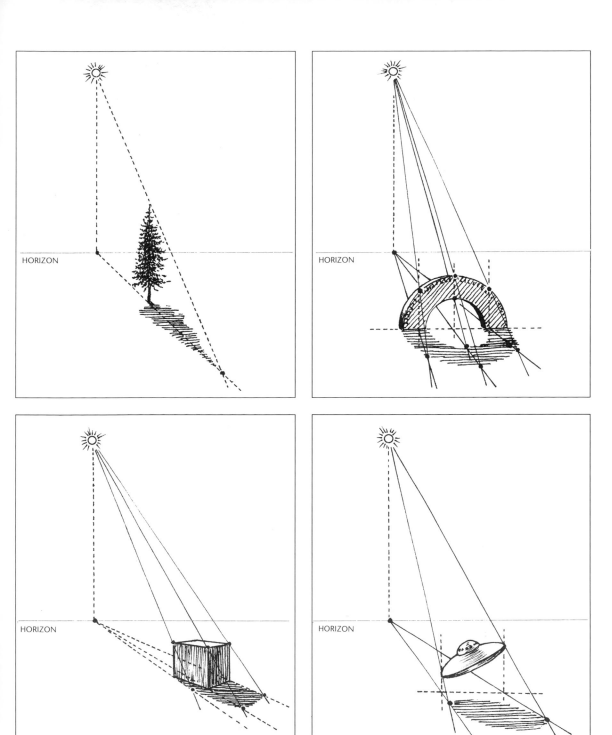

To find a point along the perimeter of the cast shadow, draw a vertical line from the point on the object you want to locate to the ground beneath it. (In the first of these examples, the tree trunk is the vertical line and the top of the tree the point we want to locate.) Then draw lines from the light source and the point beneath the light source (you may have to imagine the exact location of this point on the ground) through the top and bottom of this vertical line. Where these lines cross will be that particular point in the cast shadow. This is helpful in locating the corners of cubes in cast shadow or the shadows of floating objects, and in plotting the cast shadows of curving objects.

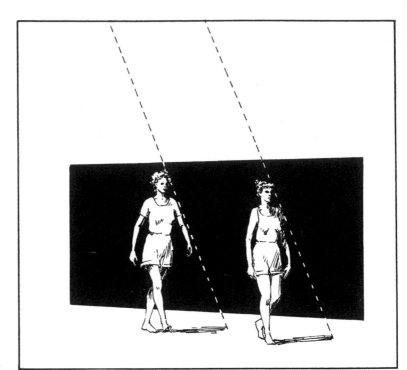

When the sun is directly overhead, as at midday, the lines you draw from the light source to the ground to calculate the length of cast shadows are virtually parallel.

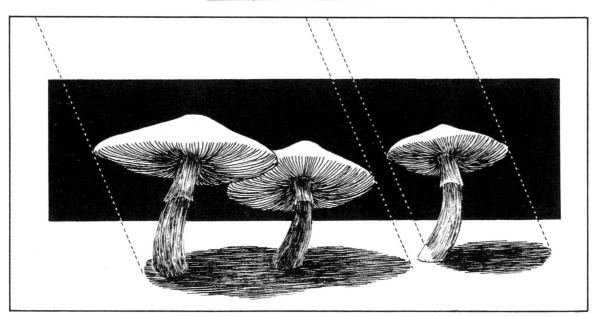

For closeup views of small objects depicted in midday sunlight, I draw the lines from the light source exactly parallel to calculate the length of the cast shadows.

Proximity Shadows

A proximity shadow is another type of cast shadow; it is the shadow you see between two objects that are touching or almost touching. When you press your hands together, for example, they are visually separated by a proximity shadow. When you hold your hands very slightly apart you still see a proximity shadow. It is important in illusionist drawing to indicate proximity shadows, because without them the viewer will have no sense of the separation that exists between one object and another, or between an object and the surface on which it rests. Imagine two limpets on a rock, one in light and one in cast shadow. In spite of the difference in lighting conditions, each will have a proximity shadow. No matter how tightly they hold the rock, they are still separate from it. Look for a proximity shadow whenever two objects make contact or near contact. Here are some important points to remember:

- Proximity shadows exist even within cast shadows.

- Proximity shadows are not greatly altered by the direction or quality of the light.

- In extremely diffused light, proximity shadows are the only cast shadows.

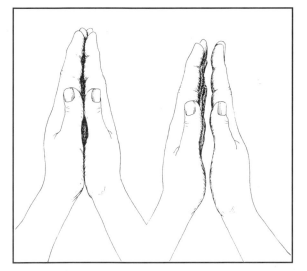

A proximity shadow is what we see as the demarcation between two objects that touch or almost touch.

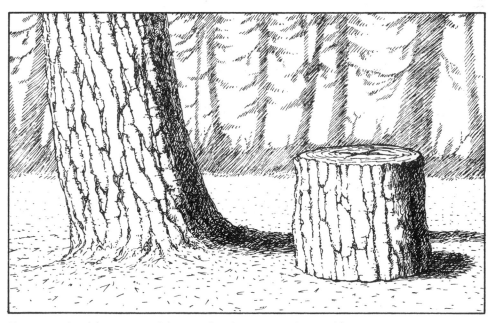

The tree trunk at left grows out of the ground and appears continuous with it. The trunk at right, however, appears to sit on top of the ground, a physical separation effectively indicated by a proximity shadow.

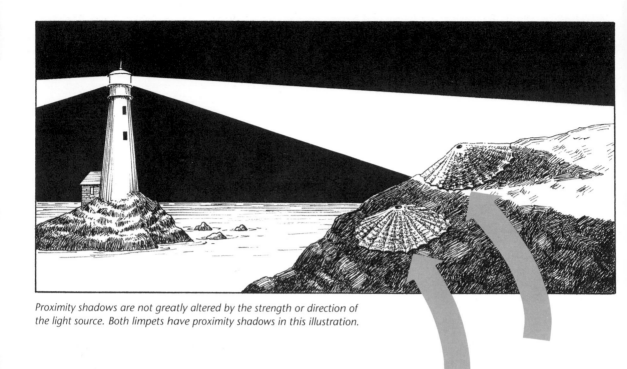

Proximity shadows are not greatly altered by the strength or direction of the light source. Both limpets have proximity shadows in this illustration.

In very diffused light, proximity shadows will be the primary shadows we see.

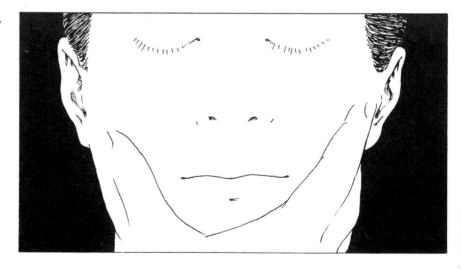

Exercises

Draw several of the basic forms with their cast shadows falling on a variety of textured surfaces.

Draw several objects with their cast shadows as they would appear first in direct light, and then in diffused light.

Next, go back to your drawings and indicate proximity shadows wherever you can see the contact points between the objects and their cast shadows.

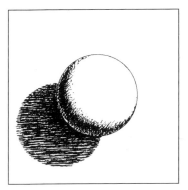 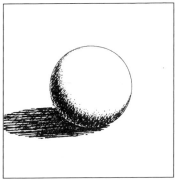 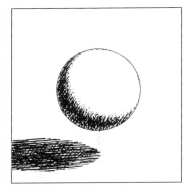

Draw objects with cast shadows that describe the environment and the object's relationship to it.

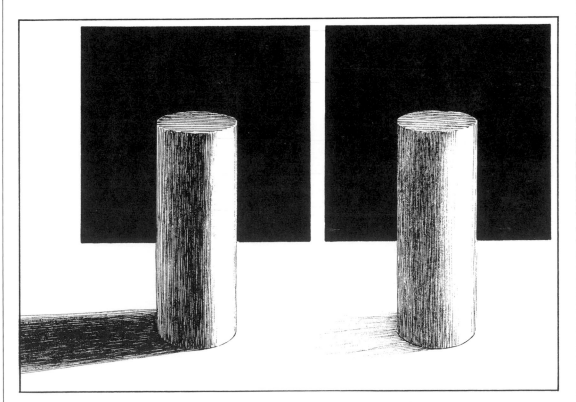

Draw an object in direct light with a cast shadow and in diffused light with a cast shadow.

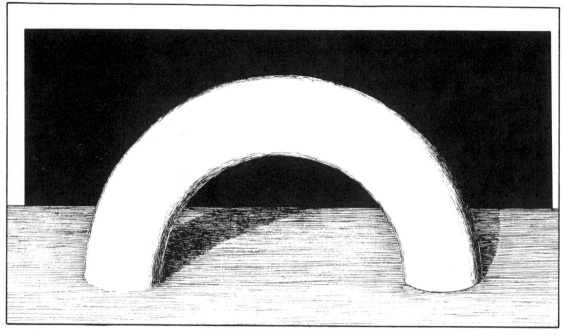

Draw an object with its proximity shadow. One end of this object
has a proximity shadow; the other doesn't.

Draw an object in
the cast shadow
of another object.
An object in cast
shadow looks the
same as it would
if seen in diffused
light, only darker.

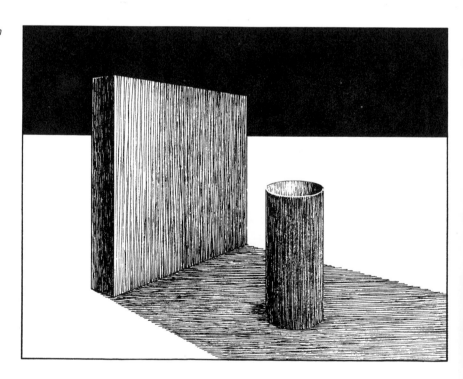

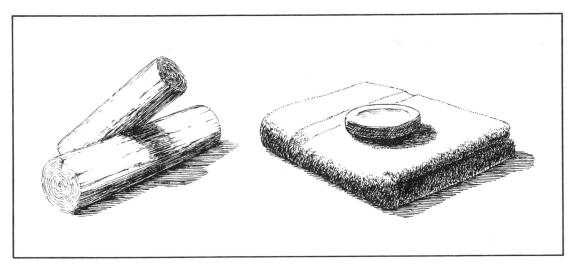

Draw objects whose cast shadows describe the texture of their environment.

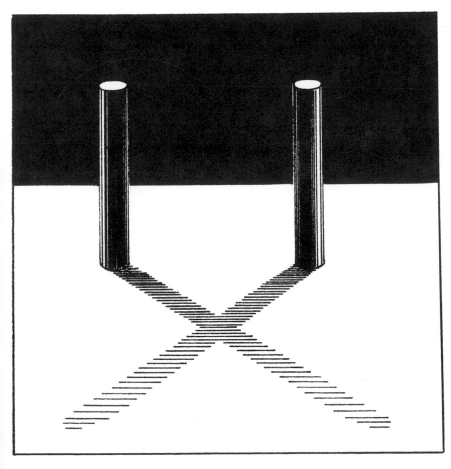

What's wrong with this picture? How do we get cast shadows to cross? How many light sources do we have? Why do we have only one cast shadow per light source?

TEXTURE

When you draw an object, how do you make it look smooth and shiny? Soft and furry? Rough and pebbly? Depicting textures convincingly in your drawings involves finding a way to translate your sense of touch into visual terms. A good way to start is to gain an understanding of how we are able to see and distinguish among textures in the physical world, and how those visual clues convey tactile qualities.

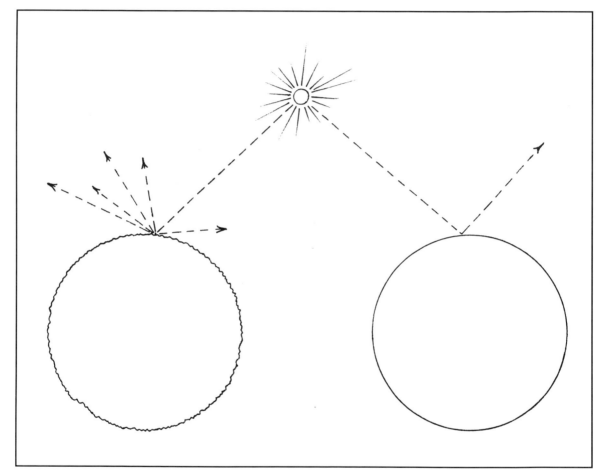

Light that falls on a rough object is dispersed in many directions. Light that falls on a smooth object bounces off it in a single direction and is seen on the object's surface as a distorted picture of the light source. Reflections help define how smooth a surface is.

How Light Defines Texture

Distinguishing between rough and smooth objects begins by understanding the way light bounces off surfaces of different textures. When light coming from a single direction strikes a rough object, it disperses in many directions, creating what is perceived as a soft-edged, or unfocused, highlight. The same light striking a smooth object will bounce off the object in a single direction, resulting in a hard-edged, or focused, highlight. On very smooth objects the highlight will be a distorted picture of the light source. This distortion will be similar to the defining patterns of light and dark we associate with the basic forms. For example, the light from a square window seen on a glossy cone-shaped object will be distorted into triangles. The round sun, seen in the highlight of a polished cylinder will appear as a stripe of light.

Side lighting best reveals the texture any object. This is important to remember when you want to give viewers the most textural information in a drawing. The texture of a rough object is most apparent in the area of transition between light and shadow; smooth surface texture is revealed by the presence of a sharply focused highlight.

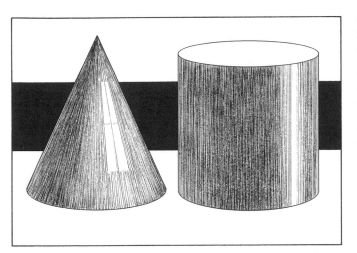

On a smooth cone, the light from a square window becomes a distorted triangular picture of the window. On a smooth cylinder, the round sun becomes a stripe of bright light. The smoother a surface, the more we depend on reflections to define its texture.

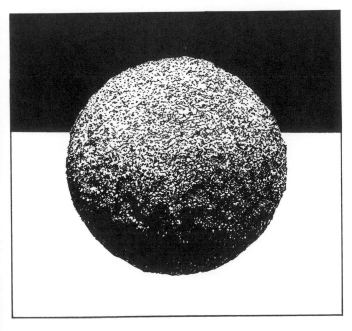

The most information about the texture of a rough surface is found where light and shadow are in transition. In the highlight area and the shadow area, texture is obscured.

The Importance of the Light Source

The apparent texture of an object changes according to the direction and quality of the light and is also affected by the number of light sources. In diffused light, the texture of an object appears less well defined, although a wider area of texture is visible. In direct light, texture is well defined but confined to a smaller area.

When the light source is behind an object (back lighting), most of what we see is in shadow and therefore in diffused light, so apparent texture is minimized. The same is true when an object is seen in front lighting; texture is difficult to see then because the area of transition from light to shadow is also small.

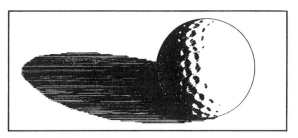 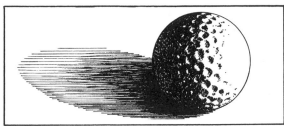

The golf ball's texture is well defined in direct light but limited to a comparatively small area. In diffused light, the texture of the same ball is visible over a larger area.

In diffused light the texture of hair is visible over the whole head.

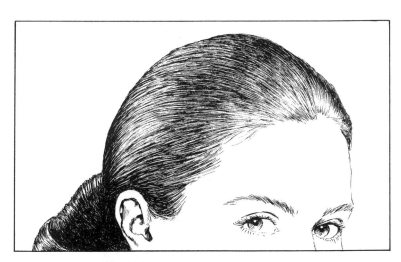

In this illustration the hair is in direct light; its texture is well defined but we see it only in a small area.

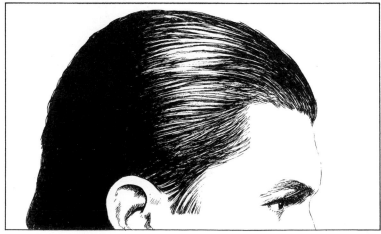

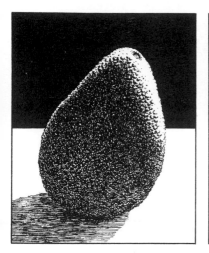

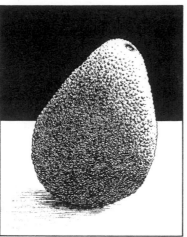

How does the quality of the light affect the texture of these avocados?

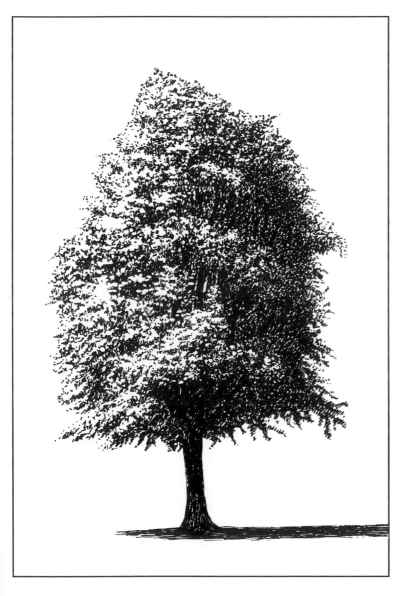

Texture is both visual and tactile. The leaf pattern of this tree forms a rough texture. Notice the greater apparent texture in the middle.

Distinguishing Textures

Texture is frequently made up of many small and not so small bumps and dents. It is important to remember that a dent is a concave shape and therefore has its darkest dark closest to the direction of the light and contains no reflected light. A bump, on the other hand, is a convex shape and thus has its darkest dark away from the light and is subject to reflected light.

The edge of a cast shadow is also a place where we look for information about the texture of a surface. For instance, a cast shadow falling across a dog sleeping on a wooden deck has subtle variations in its edges that help define the texture

of both the dog's fur and the wood. Points to remember about texture include:

- On smooth objects, highlights are well defined. The degree of focus of the highlights' edges will define the smoothness of the object; the sharper the focus, the smoother the surface.

- On rough objects, we look for texture in areas of the transition between light and shadow.

- Texture is minimized in diffused light. It is also less apparent on objects seen in front light and back light.

This texture has many concave parts. The darkest darks of the indentations are on the parts nearest the light source.

This texture is made of convex parts. Look for the bumps' darkest darks on the side facing away from the light.

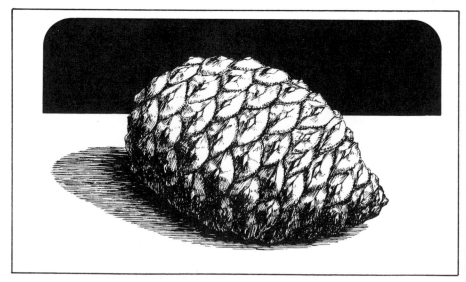

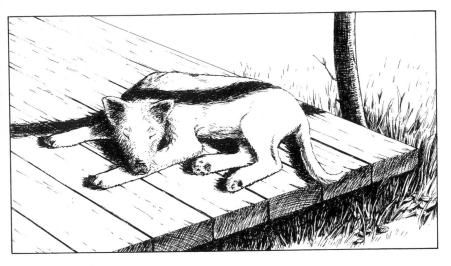

The edges of cast shadows contain information about the textures of the surfaces upon which they fall.

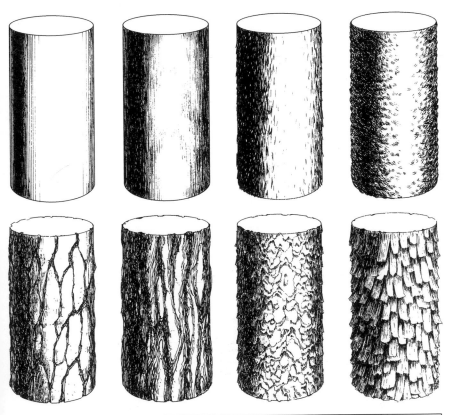

These differently textured cylinders are shown in the same lighting conditions. Notice how texture is obscured in the highlight and shadow areas. The best place to see, and thus depict, the texture of objects is in areas of transition from light to shadow. Study the ways various textures have been handled in this chapter and see which ones you can adapt to your own drawing techniques.

Exercises

Find objects of similar shape but different texture, such as a bowling ball and a baseball. Observe the difference in texture.

Draw a textured object (such as a spool of thread or a ball of twine) as it appears in direct light, then as it appears in diffused light.

Draw a cast shadow so that its edges define a textured surface.

REFLECTIONS

The highlights on objects are reflections of the light source. Even on the roughest surface a highlight (and therefore, a reflection) will appear, although we generally think of reflections as occurring mainly on smooth surfaces.

A reflection is a replication of the light source or the brightly lit part of an object on another surface. How clear this replication is and how sharply focused its edge will tell us how smooth the reflecting surface is. A reflection whose edge is soft and out of focus indicates a rougher surface than does a reflection whose edge is sharply focused. If the reflecting surface is extremely rough, the edges of reflections in it will be so out of focus that all characteristics of whatever is reflected are lost.

In drawing, reflections are useful in describing polished surfaces, water, metallic objects, and transparent objects.

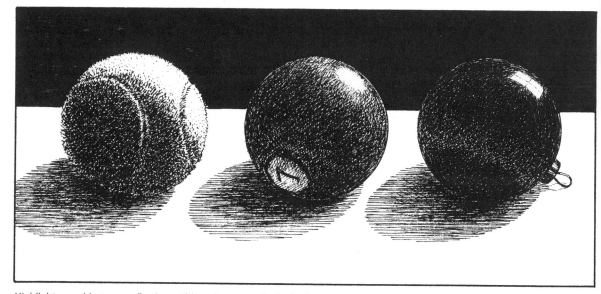

Highlights on objects are reflections. Although we usually think of reflections as appearing on smooth surfaces, they do appear on rough surfaces as well, but in unfocused form. Here, the light area on the tennis ball (left) is an unfocused reflection. The edges of a highlight tell us visually how smooth or rough an object is. Because the reflection on the seven ball (center) is less focused than the one on the Christmas ornament, we know the ornament has a microscopically smoother surface.

Value and the Reflecting Surface

When considering how to render reflections, it is necessary to differentiate between polished surfaces and mirrored surfaces and between flat and curved surfaces. Each surface has its own rules. Reflections in mirrors and metallic surfaces are unique in that they will show all the values of the reflected object.

On a glossy surface that is not metallic, only those areas of an object that are of lighter value than the reflecting surface will be seen in the reflection. All values darker than the reflecting surface will be seen as the value of the reflecting surface. For example, the reflection of an object resting on the surface of a polished white tabletop will show less of the object's detail than the reflection of the same object resting on a polished black tabletop. A polished gray tabletop will reflect everything from gray to white; all other values will be seen as the gray of the surface.

When the reflecting surface is transparent, its value is determined by what is seen through the transparency. Window glass is a reflecting surface but it has no value of its own. If what you see *through* the window is dark, then the reflection you see *in the* window will have many values and much detail. If what you see through the window is light, reflections in the window will show few values and little detail.

Reflections are transparent except when they are very light in value. When the reflection is a very bright object or a light source, the reflection is opaque. The pattern in a polished marble tabletop, for example, will be visible through all but the lightest-valued reflections on its surface.

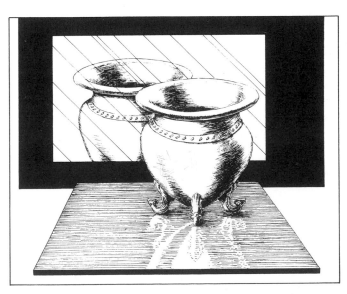

Reflections in a mirror are different from reflections in polished surfaces. A mirror reflects all the values of an object; a polished surface reflects only those values that are lighter than its own.

The reflection of an object in a polished (nonmetallic) surface will include only the values that are lighter than the reflecting surface itself. Here, the light side of the black cube and the front of the white cube are clearly seen in the reflecting surface, which is a light gray. The reflection of the front of the black cube is the same light gray as the reflecting surface, so we cannot see it. The gray cube is slightly darker than the reflecting surface, so we don't see its reflection either.

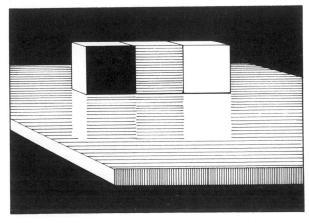

A clear glass window is a reflecting surface but has no value of its own. The value of the things you see through *the window will determine how much detail you see in a reflection* in *the window. The most detail appears in a reflection when there are dark values behind the window.*

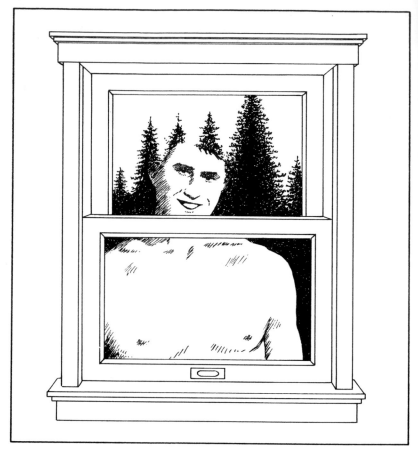

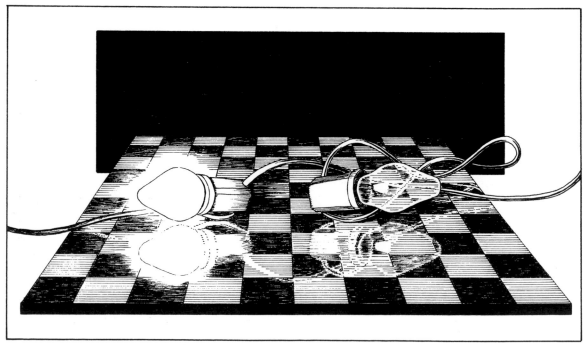

Reflections are transparent except when they are very light in value. Here, the pattern of the checker-board is visible except where the light bulb is illuminated and where the reflection is very light.

The Angle of Reflections

The reflection of a vertical object in a flat reflecting surface appears as a duplicate of the object's height. A post standing vertically in calm water will be approximately the same height in the perceived reflection as it is above the water.

If a post in the water is not vertical but leans toward the viewer, its reflection will be longer than the post itself appears. If the post leans away from the viewer, its reflection will be shorter than the post appears. These variations in reflection length exist because we are viewing the object from the vantage point of the reflecting surface.

When part of the outline of an object's silhouette is parallel to the picture plane (the paper's surface) and that outline contacts a reflecting surface, it is possible to calculate the correct angle of the object's reflection. The illustration at the bottom of the page shows how this works with cone-shaped objects.

Draw a line parallel to the reflecting surface where the edge of the object's silhouette meets that surface. (If the reflecting surface is level, the line is parallel to the horizon.) The angle from this line up to the edge of the object will be equal to the angle from the line down to the edge of the object's reflection.

An object perpendicular to the surface that reflects it has its height duplicated in the reflecting surface.

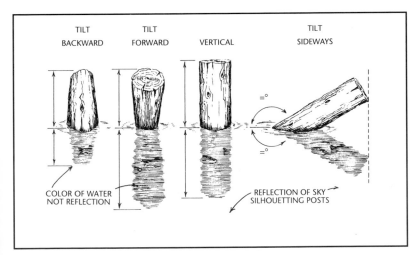

Because reflections are the view we get from the reflecting surface, we see more of an object's underside in its reflection than we do when looking at the object itself. This is why the reflection of a forward-tilting post is longer than the post itself appears. The posts seem to have dark reflections, which are actually not reflections per se but the absence, or blocking out, of the sky's reflection in the water. Except in mirrors and polished metal, there are no reflections darker than the reflecting surface. Reflections should not be confused with cast shadows.

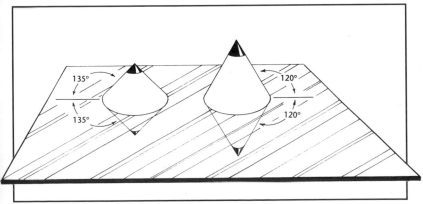

If the edge of an object's silhouette is parallel to the picture plane, we can calculate the angle of that edge in its reflection. Draw a line parallel to the reflecting surface where the object touches it. (If the surface is level, the line is parallel to the horizon.) The angle from this line to the edge of the object is equal to the angle from this line to the edge of the reflection.

Size and Shape of Reflections

Reflections on an irregular but flat reflecting surface appear larger than the object's height because the reflection is repeated in the irregularities of the surface. The most extreme example of this type of reflection is one that emanates directly from a light source. While driving behind another car on a rainy day, notice how its reflection in the wet pavement is vertically larger than the car itself, and how, when the brakes are applied, the reflections of the brake lights extend beyond the car's reflection. A sunset over water is another example; the sun's reflection is elongated because the water's surface is irregular.

Reflections on shiny curved surfaces are distorted according to the specific contour of the reflecting surface. A cylinder, for example, converts the features of objects reflected in it into parallel stripes. A reflecting sphere shrinks the image and gives a wide-angle view of its surroundings. A slightly concave surface causes the reflection of an image to appear larger than the image itself, while a very concave surface compresses and inverts the image. A cone compresses reflected images into triangles.

Mirrored or metallic curved surfaces concentrate the reflected image and increase the brightness and darkness of its values. This is our primary clue for identifying metallic objects.

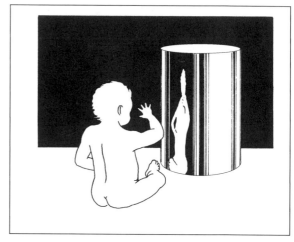

All objects become compressed into stripes when seen in reflecting cylinders.

The reflection of the brake lights in the wet pavement is longer than the reflection of the car. Reflections of light sources in irregular surfaces are often quite long.

Concave spherical reflecting surfaces shrink and invert images reflected in them. If the concavity is slight, it will magnify the image.

Objects reflected in conical surfaces appear as triangles.

The curved metal ferrules of these brushes concentrate the values they reflect into intensified lights and darks, which are our primary clue to recognizing polished metal surfaces.

Reflections in Water

When looking at water, we are best able to see into the depths at an angle of about 45°. Viewed at angles of more or less than 45°, water becomes an increasingly reflective surface. When standing at the edge of a pond, we can see through the water to the bottom near the shore. As we look farther out over the pond (at an angle of less than 45°), the water's reflectivity increases. If we stand in the water and look down (at an angle greater than 45°), we see our own reflection.

In turbulent water the dark peaks we see are caused by the water's transparency. The peaks indicate that the water's surface is at a tilt that approximates a 45° angle. These darks are not a function of light and shadow unless the water is muddy or otherwise no longer transparent. The darks are caused by the opportunity to see into the depths at a 45° angle. If the water is shallow these darks will be only as dark as the bottom of the water. The proof that we are not looking at darks created by shadows is that regardless of the direction of our gaze or the direction of the light, they remain consistent. The light areas are reflections.

Standing at the shore, we can see into the water, because it is transparent when viewed from close by; farther out, we see it as a reflective surface. We are best able to see into the depths of water at an angle of about 45°. When our view of the water is at an angle of less than 45°, we see more reflection.

The dark peaks in turbulent water are not shadows. They are the transparency we see in water when our angle of vision with the surface is around 45°. Between these peaks are reflections.

Exercises

Observe and draw reflections from your surroundings. Draw the reflection of a cup in a polished tabletop, and the reflected highlights in a drinking glass. Note how the highlight describes the form of the glass.

Look out a window and observe where you can see your own reflection.

Find a large body of water and note how close to your point of view you can see into it, and at what point, farther away, you begin to see reflection.

To help confirm your understanding, draw your observations.

TRANSPARENCY

For an object to be transparent it must have a smooth surface; thus, all
transparent objects have sharply focused highlights. This is one of the clues we
use to detect transparent objects. A transparent object whose surface is slightly
less smooth, like wax paper, frosted glass, or a shower curtain, is *translucent.*
Translucent objects allow light through them but detail is obscured. Their
highlights are less sharply focused. Observation and use of these simple
phenomena will help you create the illusions of transparency and translucency
in your drawings.

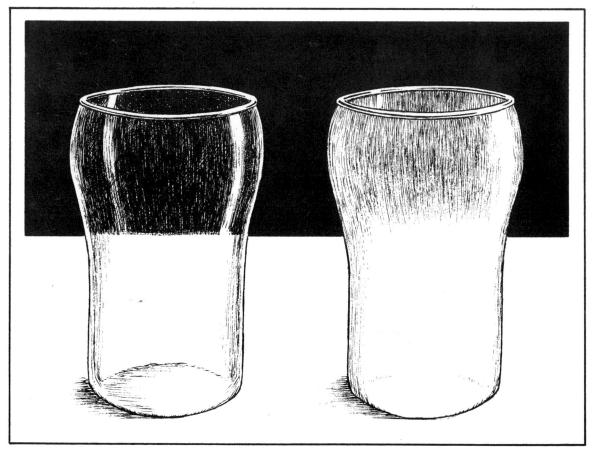

*Transparent objects have smooth surfaces and focused highlights. Translucent objects, like
frosted glass, have unfocused highlights. Details through translucent objects are obscured.*

Hollow vs. Solid Transparent Objects

Transparent objects come in two varieties: hollow, such as an empty glass jar, and solid, such as a glass jar filled with water. Because their walls are solid, hollow objects are subject to the same rules that govern the way we depict transparent solid objects, but the rules apply only to the hollow object's walls. When a jar is filled with water, the transparency of the glass and that of the water combine in such a way that the jar is perceived as if it were solid glass.

There are two areas of light on a transparent solid: the primary highlight, which appears just where it would on a nontransparent object; and a secondary highlight within the object, which appears opposite the primary highlight and is often brighter than it. This secondary highlight is one feature that indicates a transparent solid. Translucent objects will also have a secondary highlight.

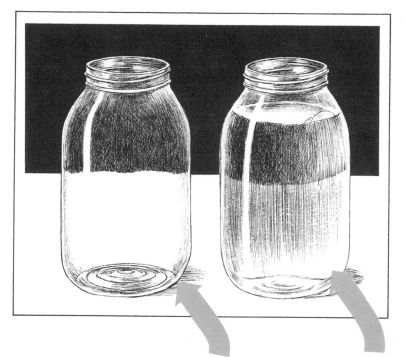

A hollow transparent object, like the empty jar at left, is visible at its edges. What is seen through it remains relatively unchanged. One way we can tell that a transparent object is solid, like the water-filled jar at right, is by the way it distorts the image of what is behind it.

Transparent solid objects have two highlights: a primary highlight, which appears in the same place it would on any nontransparent object, and a secondary highlight, which appears within the object on the side opposite the primary highlight. The secondary highlight is one clue for identifying a solid transparent object.

Distortions

Transparent solid objects are also defined by the specific ways they distort the images of things seen through them. A transparent sphere always inverts the image of whatever is behind it. A transparent vertical cylinder causes images to be seen in reverse, while a horizontal one causes images to invert. Images seen through a solid transparent cone appear triangulated and reversed. Cubes shift what is seen through them slightly to the side or above or below. A window can be thought of as a slice of a cube visually shifting the position of objects seen through it; the thicker the glass, the greater the shift.

Transparent hollow objects share all of the characteristics of transparent solid objects, but the secondary highlights are seen only in the hollow object's thin walls. These walls distort what is seen behind them, but not as much as transparent solids do. In most cases the distortion is a shifting of background edges, similar to the distortion caused by transparent cubes. If the walls of the transparent hollow object curve or vary in thickness, the contour of what is seen behind the object will appear to bend.

If we look through the middle of an empty glass jar, we can see what is behind it. But if we look at its sides, we cannot see through as well, because there the glass is thicker and more opaque. We identify a hollow transparent object by seeing its edges, its primary highlight, and the distortion at its edges of what is seen through it.

At left is a hollow transparent sphere, at whose edges background images appear distorted. At right is a solid transparent sphere, which inverts images seen through it.

A solid transparent cone reverses and triangulates images seen through it. A hollow cone just distorts the images seen through it at its edges.

At near right is a hollow transparent cylinder, at whose edges the background appears distorted. At far right is a solid transparent cylinder, through which background images appear in reverse. If this solid cylinder were horizontal, the background images seen through it would be inverted.

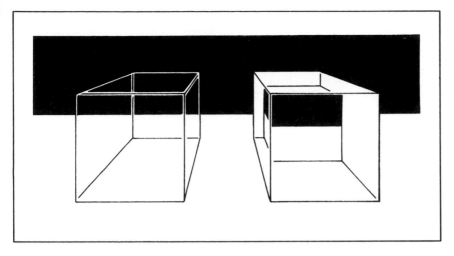

A solid transparent cube shifts the image of what appears behind it from side to side or up and down, depending on the angle and thickness of the cube. A hollow transparent cube does the same, only less so.

The edges of a hollow transparent object distort the image of whatever is viewed through it. The thicker the walls of the object, the greater the distortion.

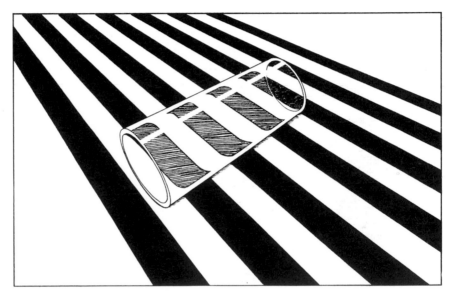

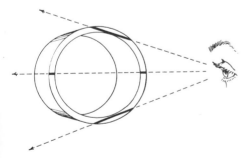

When we look at an empty glass, we look through less glass in its middle than we do at its sides. There, the glass seems to form nearly opaque "lines" that define its silhouette.

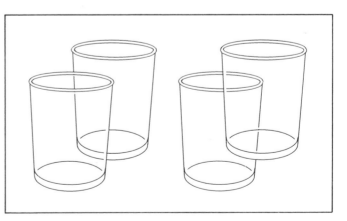

What's wrong with this picture? Hollow transparent objects are most clearly defined by their edges. The glass at far right seems to float in front of its mate because of the way its edges have been drawn.

Creating the Illusion of Transparency

You can create the illusion of transparency in your drawings if you observe how light, shadow, and value behave on transparent objects under various conditions. For instance, both hollow and solid transparent objects have a primary highlight, and a secondary highlight opposite it. The difference is, on a solid transparent object the secondary highlight appears *within* the object, while on a hollow transparent object the secondary highlight is seen only in the object's *walls.*

Value contrasts are lessened when seen through transparent objects. For example, when you look through a window, the light values you see will be slightly darker and the darks slightly lighter than if the window was not there. A clean window lets you see stronger value contrasts than a dirty one.

The cast shadow of a hollow transparent object is usually a restatement of the object's transparency: transparent in the middle and opaque at the edges. We see darker cast shadows at the edges of a hollow transparent object because there, at its walls, the object is thickest and blocks more light.

The cast shadow of a transparent solid has a bright spot of light within it, caused by the secondary highlight that appears on the side of the object opposite the primary highlight.

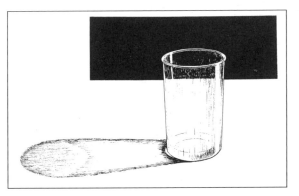

The cast shadow of a hollow transparent object is light in the middle and dark at the edges.

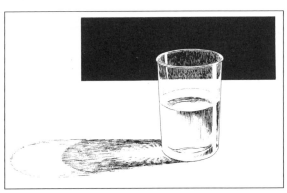

The secondary highlight on a solid transparent object causes a bright area of light within the object's cast shadow.

Value contrasts are reduced when viewed through a transparent object. Here, a pane of glass floats in front of the curving stripes. We don't see the glass itself, but can see its effect in the reduction of contrast between the black and white stripes.

Each of the following elements will imply transparency. The more you can include in your drawing, the stronger the illusion you will create.

- A primary highlight that is hard-edged indicates that the surface it appears on is smooth (transparent objects are smooth).

- A secondary highlight within the object and opposite the primary highlight implies a transparent solid.

- A secondary highlight in the object's wall opposite the primary highlight implies a hollow transparent object.

- A cast shadow that is light in the middle and dark only on the edges implies a hollow transparent object.

- A cast shadow with a brightly illuminated area in an otherwise dark shadow implies a transparent solid.

- All transparent objects shift the values of what is seen through them toward middle values.

- Solid transparent objects distort (reverse, invert, or shift) things seen through them.

- Only the edges of transparent hollow objects significantly distort their background.

The iris of the eye (the colored part) is covered by a solid transparent lens called the cornea. See how the primary and secondary highlights on the cornea affect the light on the iris. The tear is a transparent solid and is similarly affected.

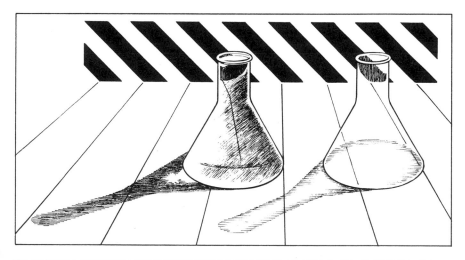

Which of these transparent objects is hollow and which is solid—and how do you know?

Exercises

Observe, then draw an empty transparent water glass and its cast shadow. As you look at the glass, look for the secondary highlight in its base and walls.

Fill the glass with water and look through it. Observe the distortion of the background and the change in the cast shadow. Also notice the increase in size of the secondary highlight.

Since the secondary highlight is the main distinguishing characteristic of transparent objects, it is sometimes helpful to accentuate it in your drawing.

Observe and draw several other transparent objects as well.

ELLIPTICAL PERSPECTIVE

How do you visually determine the incline of a hill? How can you determine the form of a piece of cloth just by looking at the pattern on it? How do plates on the near side of a table look different from those on the far side? Elliptical perspective is the primary clue we use to understand and depict the contours and curvature of surfaces and the distance between one surface and another.

This is how elliptical perspective works: If you look at a drinking glass from directly above, the opening, or rim, is a circle. If you look at the glass from the side, the opening appears as an ellipse. If the opening is at your exact eye level, the ellipse is so narrow that it appears as a straight line. When you raise and lower the glass, the vertical measurement of the ellipse appears to change—in other words, the ellipse appears rounder or flatter, depending on where the glass is in relation to your eye level. So long as the glass remains upright, each step you move it above or below your eye level results in an increase in the vertical measurement of the ellipse.

When you look at the rim of a glass so that the opening is almost level with your eyes, it appears as a narrow ellipse. When you look at the rim from directly overhead, it looks like a circle.

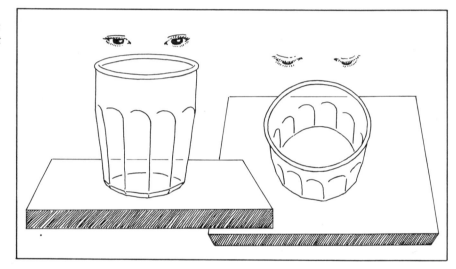

This transparent cylinder is divided into four sections that are parallel to one another. Notice how the elliptical shapes that define each section become rounder as they get farther away from your eye level.

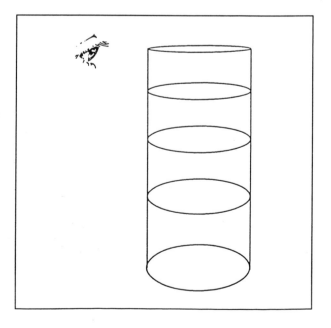

Minor and Major Axes

As artists we are interested in two measurements on an ellipse: the minor axis, which is the shortest line that can be drawn through the center of the ellipse, and the major axis, which is the longest line that can be drawn through the center. The major and minor axes are perpendicular to each other.

We look to the minor axis to determine the relation of an object's surface to our eye level, the front-to-back tilt of a plane, and how close a plane is to us. For example, if we tip a glass to drink from it, the minor axis of the ellipse—the rim of the glass—gets longer and depicts the forward tilt of the glass. So, to draw a plane so it appears to tilt forward in space, increase the length of its minor axis.

To understand how elliptical perspective works in the perception and depiction of distance, imagine several glasses on a table, some close to your view and others far away. The ellipse formed by the rim of a glass close by will be rounder (in other words, will have a longer minor axis) than that of a glass on the far side of the table (which will have a shorter minor axis). Regardless of the glasses' size, if their rims are at the same height, those that appear as narrow ellipses belong to the glasses farthest away from you.

The horizon is also called the eye level. In the same way that the opening of a glass appears to narrow as it nears your eye level, circles on a flat plane appear to become progressively narrower ellipses as they approach the horizon (eye level). The circles farthest away from you (closest to the horizon) will have the shortest minor axis; those nearest you will have the longest. Imagine water lilies on a pond. The water is a plane on whose surface the plants' circular leaves rest; leaves in the distance appear narrower (i.e., have a shorter minor axis) than those nearby.

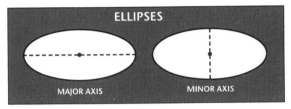

The minor axis of an ellipse is used to determine the plane's relation to eye level, forward-backward tilt, and distance from the viewer. The major axis is used to establish the sideways angle, or tilt, of the plane.

Here, the smaller, narrower ellipses give the impression of being in the distance, while the wider and larger ellipses seem close to the viewer. These shapes are arranged to imply a flat horizontal plane.

Water lilies are a good subject for observing how elliptical perspective works. The water is a flat plane on which the round leaves rest; with increasing distance, the leaves appear as progressively narrower ellipses.

Seeing Different Shapes in Elliptical Perspective

All shapes on a plane are affected by elliptical perspective. Imagine odd-shaped leaves floating on water. As they recede toward the horizon, their apparent vertical measurements diminish faster than their horizontal measurements—in the same way and at the same rate as with ellipses.

Picture a landscape with a calm lake or river. In such a setting, note how the shorelines of land forms—peninsulas, rocks, or islands—define the plane of the water. Place the shorelines in imaginary ellipses and you will see that those closer to you are more rounded—have greater minor axes—than those in the distance. In the far distance, the shorelines fit into ellipses so narrow that they are almost straight lines.

In this illustration the leaves have been drawn to imply that the plane on which they rest is more vertical than the one in the preceding water-lily illustration. This effect has been achieved by making the minor axes of the leaves decrease from foreground to background in a comparatively slow progression.

When flat shapes are seen at an angle or in the distance, their horizontal measurements change the least and vertical measurements change the most.

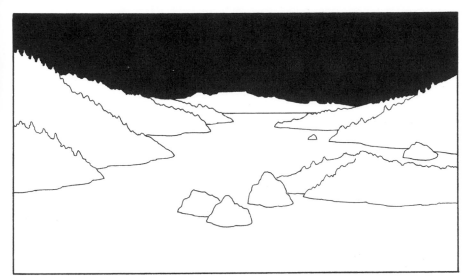

Right. *In this illustration, the shorelines of the various landmasses fit into imaginary ellipses that become increasingly round as they advance toward the foreground. This correctly establishes the plane of the water.*

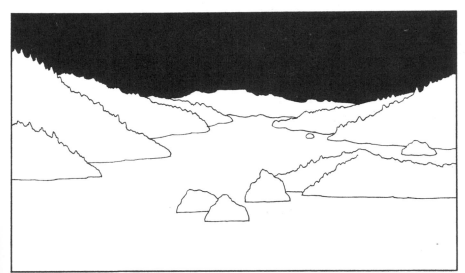

Wrong. *Here the elliptical perspective is subtly reversed. The near shorelines are flat, straight lines (i.e., the imaginary ellipses narrow), while in the distance they become more rounded.*

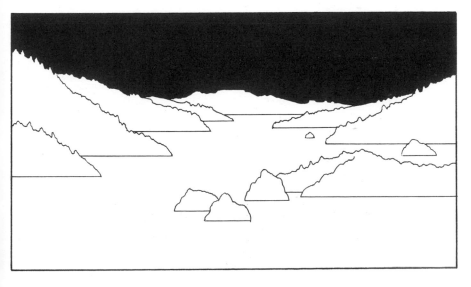

Wrong. *In this example the shorelines are all drawn as straight lines; thus, no illusionistic plane is established, and everything seems to float in the air.*

Using Ellipses to Define Surface Contours

Ellipses are also used to define the curvature of a surface. The key is to vary in specific ways the minor axes of the ellipses that describe that surface. A change in minor axis from one area to another indicates a change in the contour of the surface.

The greater the variation in the ellipses' minor axes, the more changes in surface contour are indicated. Study the illustrations shown here and notice how the minor axes have been handled to describe both flat and curved surfaces.

In this illustration the ellipses have been arranged to create the illusion of a flat plane. As these shapes recede toward the background, their minor axes diminish in size at a constant rate. Compare this rate of change with that in the illustration at right.

Here a curved surface is indicated. In the foreground, where part of the surface is nearly parallel to the picture plane, the changes in minor axes are gradual. As the surface curves away from the picture plane, the ellipses' minor axes diminish rapidly.

In the illustration at near right the ellipses have been arranged to create the illusion of a horizontal plane that recedes in space, then curves upward into a vertical plane. This is accomplished by making the minor axes progressively smaller, then larger. At far right, the ellipse pattern creates the illusion of a large, horizontal cylinder.

The texture of this tree trunk is an example of how ellipses describe a curved contour.

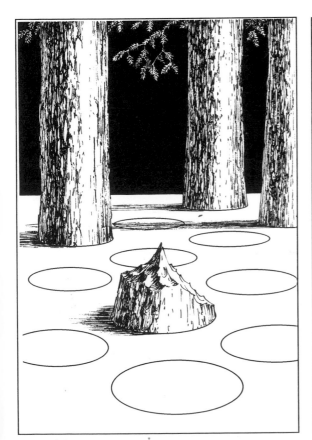

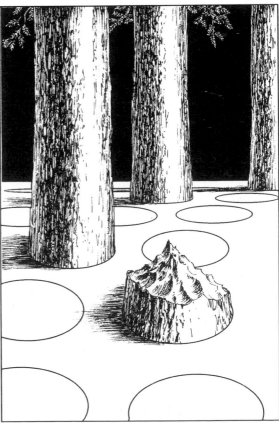

Just as the ellipses here indicate a flat plane, so too do the bases of the tree trunks, which are circular and therefore fit into imaginary ellipses appropriate for circles seen at that angle and distance.

Here the ellipses and the bases of the trees are arranged to create the impression that they rest on a curving (cylindrical) surface.

The Major Axis and Surface Contour

Up to this point all variations in surface contours have been created by varying the minor axes and placement of the ellipses that describe those surfaces. Now we consider the role of the major axis.

The major axis of an ellipse is used to determine the sideways incline, or tilt, of a plane. For a surface to appear level and flat, the major axes of the ellipses that describe that surface must be parallel to the horizon. And, the minor axes must gradually decrease as the ellipses recede into the distance.

A tilt in the major axis of an ellipse—meaning it is not parallel to the horizon—indicates a laterally inclined plane. The angle of the tilt describes the angle of the plane.

Some of the major and minor axes of these ellipses have been altered in order to describe a hill and valley. Can you see the changes in contour and how they were created?

Other Indicators of the Angles of Planes

The shapes of cast shadows are what we most commonly use to identify and describe the angles of planes, and it is the major axis of a cast shadow shape that shows us the degree of a plane's incline. Depending on your subject, there are other visual clues. In the landscape, for example, look at the base lines of bushes, rocks, and tree trunks, lichen and moss on trees and rocks, patches of wildflowers in the grass, and even the color variations in the grass. In a dining room with a table set for dinner, where the ellipses of the plates, glasses, and bowls are all parallel to the horizon, the objects on the far side of the table will have slightly shorter minor axes than those on the near side. Wallpaper with a repeating pattern offers another opportunity to describe planes according to elliptical perspective, as do patterns in folded, draped, and wrinkled clothing.

 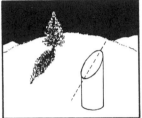 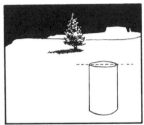

Note the similarities between the angles of these cut cylinders and the cast shadows of the trees. In all cases, the major axis of the cylinder's and the cast shadow's ellipse is used to define the incline of the plane.

The cast shadows of the oaks serve to define the contours of these hills. When you draw, use cast shadows to describe your subject's surroundings.

In this illustration, the elliptical perspective of the sweater's pattern defines the internal contours of the woman's form. When drawing, use the repeating patterns you see in clothing, drapery, and the like to explain changes in the fabric's direction.

In summary, when you want to convey surface contours and curves, two main points apply:

- The minor axis of an ellipse indicates the curvature, distance from the horizon, relation to eye level, and front-to-back tilt of a plane.

- The major axis of an ellipse indicates the sideways (lateral) angle, or tilt, of a plane.

With just a small stretch of the imagination, you should be able to see most shapes on a plane within ellipses. Very complex undulating surfaces are most easily interpreted this way. Because elliptical perspective provides such strong clues to the perception of planes and their contours, you should always look for opportunities to accentuate it in your drawings.

Here the elliptical patches of light within the cast shadows describe the curvature of the path.

In this illustration the cast shadows across the road describe its ruts and the contour of the land on either side of it.

There are at least ten uses of elliptical perspective in this drawing. Can you find them?

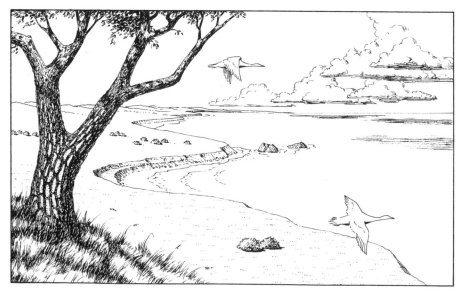

Answers: the bottoms of the clouds; their cast shadows on the water; the wave shapes; the waterlines of the rocks; the shoreline shapes; the base lines of the distant shrubs; the foreground tree's bark texture; the tree's cast shadows on the grass; its inclined base line; and the angle of the birds in relation to eye level.

Exercises

Because it is important to teach the hand what the mind now knows, included here is an illustration of equally spaced, equal-size black circles, which you should draw on a full sheet of paper at a larger scale or enlarge on a copier.

Roll your drawing or photocopy of the black-circle pattern and observe how the circles become ellipses that define the curve of the paper. On a separate sheet, draw what you see, taking care that your ellipses are rounder or flatter according to their position along the contour of the form (a cylinder) they are describing. Now fold the page a few times, creating multiple planes. Observe, then draw the ellipse pattern as it now appears, conveying the planar changes through your handling of the inclines and proportions of the ellipses' major and minor axes.

On a full sheet of paper, draw or photocopy at a somewhat larger scale the pattern of equal-size, equally spaced black circles. Place your sheet of circles on a flat surface and position yourself so you are not looking at it from directly overhead. On a separate piece of paper, draw the pattern as it now appears—as a series of ellipses whose minor axes grow smaller as the shapes recede away from you. Then, take your original sheet of circles and roll or fold it into various configurations. On separate sheets, draw what you see—the pattern as it describes the contours and angles of different planes.

LINEAR PERSPECTIVE

Perspective is what lets us control the spatial elements of our drawing—what makes visual realism, or illusionism, look "right." You have already been introduced to the perspective of the cube. We now explore linear perspective in greater depth. And depth is what linear perspective is about. When you understand it, you can confidently establish the illusion of depth in your pictures.

Railroad tracks appear to get closer together as they recede in space toward the horizon. The point where they appear to meet is called the vanishing point.

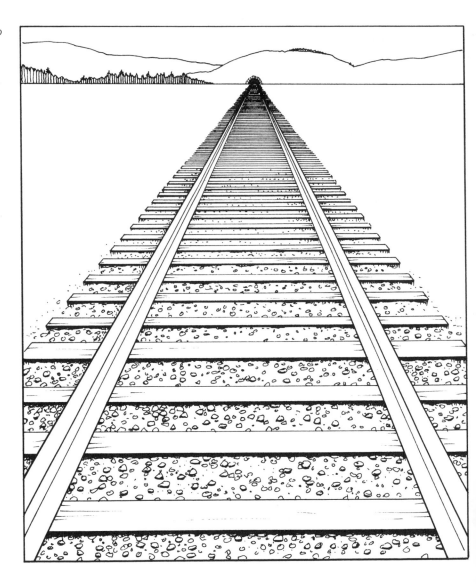

Basic Concepts and Terminology

In considering linear perspective it is necessary to return to the concept of the picture plane. As defined previously, the picture plane is the actual two-dimensional surface of your paper or canvas. The image you create on that surface is drawn as if you were seeing your subject through the picture plane.

The other key concept to understand is the horizon line, which is, of course, the horizon; it is also your eye level. When you sit looking out a window at an ocean view, the horizon appears near the bottom of the window. When you stand, the horizon appears higher in the window. If you are tall enough or the window is low enough, the horizon will be above the top of the window.

Imagine a plant in a flowerpot hanging outside the window. If you can see inside the top of the flowerpot, the horizon line will be high in the window, because you are looking down. If you see the bottom of the pot, the horizon line will be low in the window, because you are now looking up. So, when you draw, if you want to give your viewer the impression of looking up, put the horizon line low on the page. To give the impression of looking down, put the horizon line high on the page.

Study the list of terms below so that you can more easily grasp the text and illustrations that follow.

The picture plane is the actual surface of your drawing or painting. The image is what you imagine you see behind the picture plane.

Perspective Terms

Ground line: A line drawn to establish the surface on which an object rests; it is used to determine accurate vertical measurements in perspective drawings. The ground line is always parallel to the horizon line. When making a perspective drawing that shows top and side views, you place the side view of an object on the ground line.

Horizon line: The actual horizon, where earth and sky appear to meet, excluding obstructions like hills or mountains. Also called eye level.

Parallel: Said of any two lines or surfaces that are always the same distance from each other.

Perpendicular: At a right, or 90°, angle to a given line or plane. An absolutely vertical line and an

absolutely horizontal line are perpendicular to each other.

Picture plane: The surface of your paper or canvas. The image you create on the picture plane gives the impression that your subject is behind this surface.

Plane: Any flat surface, such as a wall, floor, ceiling, or level field.

Station point: The artist's position relative to the object he or she is drawing.

Vanishing point: A point at which parallel lines receding into space appear to converge. If the lines are parallel to the earth they will meet on the horizon line.

One-Point Perspective

To understand how one-point perspective works, imagine yourself standing in the middle of a straight railroad track (as in the illustration on page 90). You know the rails are the same distance apart throughout their length, and yet as you look into the distance, they appear to come together and meet at a point on the horizon. This point is called the "vanishing point" because here the rails appear to converge and vanish.

Each set of receding parallel lines has its own vanishing point. On level ground, a road that travels straight away from you is defined by a single pair of parallel lines, and will have one vanishing

point located on the horizon line. If the ground is not level, the edges, or boundaries, of the road will consist of several sets of parallel lines, and therefore the road will have more than one vanishing point.

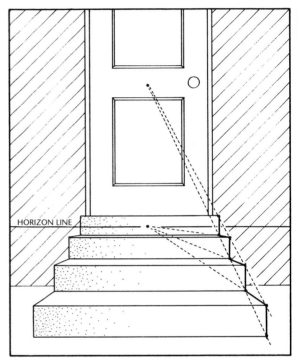

Stairs in one-point perspective are similar to the road. The incline of the stairs has one vanishing point, while the level tread has another. To draw a staircase in one-point perspective, start by establishing the height of the bottom step. For the incline, draw perspective lines from the top and bottom corner of the lower step to your chosen vanishing point above the horizon line. (In this example, the horizon line represents a dog's eye level.) Draw a line from the top corner of the bottom step to a vanishing point on the horizon below your first vanishing point. This is the line of the first tread; where this line crosses the other perspective lines gives you the location of the back of the tread. From the back of the tread, make a vertical line; where the vertical line crosses the perspective lines, draw a new tread. Continue to zigzag your way up the stairs.

If this road were on level ground, it would have just one vanishing point on the horizon. Changes in terrain call for more than a single vanishing point. An uphill stretch of the road has a vanishing point that rises above the horizon, while a downhill stretch has a vanishing point that sinks below the horizon.

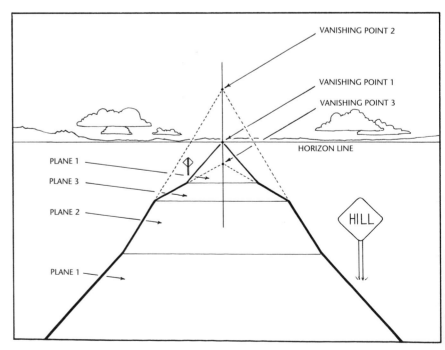

Picture a road that heads in a single compass direction but travels up and down hills. Each incline or decline is a change of plane; each change of plane is defined by a different pair of parallel lines representing the road's boundaries. An uphill stretch of road has its vanishing point above the horizon line. A downhill stretch of road is defined by a new set of parallel lines, which will meet at a vanishing point below the horizon line. Even though we now have more than one vanishing point, this is still considered one-point perspective.

A road that winds along level ground offers another example of how more than one vanishing point can exist in one-point perspective. Each straight section of the road has its own vanishing point, as the top illustration on this page shows. The road's width is maintained with each change of direction by a horizontal line that crosses the perspective lines. Where these intersect, the road heads toward a new vanishing point.

Like the road described above, a fence on level ground that changes direction will have a vanishing point on the horizon line for each such change—one for each new set of parallel lines.

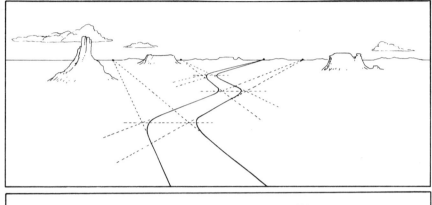

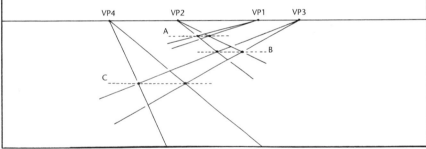

This winding road twists in four separate directions, each with its own vanishing point. The horizontal lines A, B, and C are used to maintain the correct width of the road throughout its direction changes.

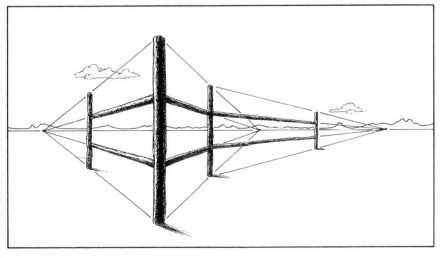

This fence on level ground travels in three different directions. Each direction has its own vanishing point on the horizon.

One-point perspective is commonly used when depicting boxlike structures and room interiors that have one face or wall parallel to the picture plane. The horizontal and vertical edges of that face are perpendicular. The parallel lines that define all the other faces of the box recede and converge at a point on the horizon line.

Remember that in one-point perspective, verticals and horizontals that are perpendicular to each other describe surfaces that are parallel to the picture plane.

A box with a wall parallel or nearly parallel to the picture plane is in one-point perspective. On the walls parallel to the picture plane, the verticals and horizontals are perpendicular to each other. All receding parallel lines meet at the same vanishing point. (If the box is level, the vanishing point will be on the horizon line.)

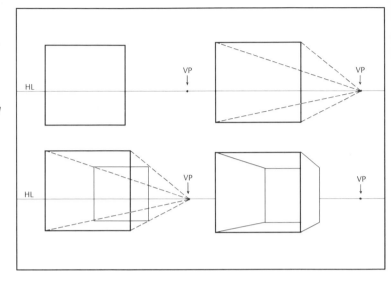

This chest of drawers is drawn in one-point perspective. The vertical and horizontal lines are perpendicular on all surfaces parallel to the picture plane. All other receding lines meet at the vanishing point above the chest.

Drawing Equally Spaced Objects in Perspective

To find the center of any rectangle in perspective, draw two diagonal lines that join the rectangle's corners, forming an X. The intersection of the two diagonals—the center of the X—is the center of the rectangle.

When you are drawing objects in perspective that require equal spacing, such as telephone poles or parking meters, begin by placing the first in the series—say, a parking meter—in your composition. To establish the direction of a row of parking meters, draw perspective lines from the top, bottom, and middle of the first meter to a vanishing point on the horizon. Choose the position of the second meter; its height is determined by the top and bottom perspective lines. Now find the midpoint on the second meter. Draw a diagonal line from the top of the first through the midpoint of the second, continuing the diagonal to the bottom perspective line. Where this diagonal and the bottom perspective line intersect is where you place the base of the third parking meter (as with the others, the height of this meter is determined by the top perspective line). A diagonal line drawn from the top of the second parking meter through the midpoint on the third meter to the bottom perspective line will give you the location of the fourth one. Continue this process until you have the number of parking meters you need.

To find the center of any rectangle in perspective, draw diagonal lines from corner to corner, forming an X. Where the diagonals cross is the perspective center.

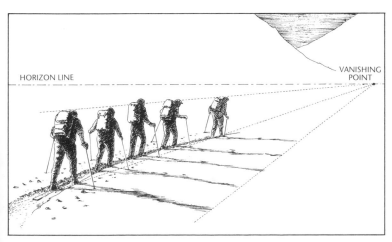

These cross-country skiers are all approximately the same height. The height of the figures in the foreground and background and the length of their cast shadows are calculated using perspective lines.

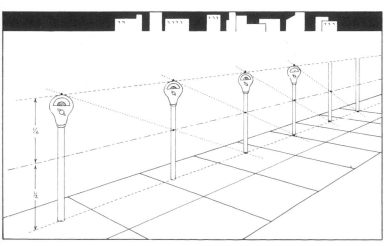

To draw equally spaced objects in perspective, locate the first object in the series—parking meters in this case. Draw perspective lines from the top, bottom, and middle of the first meter to a vanishing point on the horizon. These lines establish the direction of the rest of the meters. Choose the position of the second parking meter. Its height is determined by the top and bottom perspective lines. Now draw a line from the top of the first meter through the middle of the second one, continuing the line so it meets the bottom perspective line. At that intersection, place the third meter. Continue until you have the number of meters you want.

Two-Point Perspective

Two-point perspective is used when only the vertical edges of rectangular objects are parallel to the picture plane, as opposed to one-point perspective, in which whole sides of an object—and therefore horizontal *and* vertical edges—are parallel to the picture plane.

In two-point perspective, only the verticals are truly parallel to each other. All lines or edges parallel to the flat earth will appear to point to locations on the horizon. Each set of receding parallel lines has its own vanishing point. Sets of parallel lines that are parallel to one another share a vanishing point.

We will now apply two-point perspective to drawing a specific subject, a square shed with a peaked roof. The shed is seen from a corner. The room is a perfect cube, meaning that its height, width, and depth are the same. The steps we follow here apply no matter what the dimensions are of the object you are drawing.

This is an example of a subject drawn in two-point perspective. The horizon is very high in this picture, indicating that we are looking down at the books.

Top and Side Views, Station Point, and Picture Plane

We start with a top view of the shed, represented by a square with a line drawn from the middle of one side to the middle of the opposite side. This middle line is the ridge of the roof. The square is placed at the top of the page at an angle.

Draw a horizontal line that touches the lower corner of the shed's roof seen in the top view. This line represents the top view of the picture plane (like the paper seen from its edge).

Off to one side of the page, draw a side view of the shed using the same scale as you did for the top view. It will look like a square with a rectangle on top for the roof.

Now choose a station point, the imaginary place from which the subject will be seen. (It is also the artist's location.) Place it at a location near the bottom of the page, directly below the near corner of the shed. If you place the station point close to the top view of the shed, your drawing will give viewers the impression of standing close to the shed. Placing the station point far from the top view gives the impression of seeing the shed from a distance.

To achieve accurate measurements in two-point perspective, start by placing a correctly proportioned top view of your subject at the top of the page at an angle. (In this demonstration, the subject is a square shed with a peaked roof.) Draw a side view of the subject, in the same proportions as the top view, to the right of the page. Then place a station point below the top view where you imagine yourself standing to see the subject. Place the picture plane next to the top view. Because we are looking down at this part of the drawing, we see the picture plane edgewise, so it is only a horizontal line.

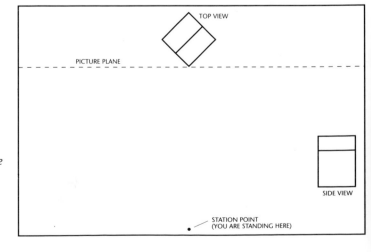

Vanishing Points and Horizon Line

Next, locate the vanishing points. From the station point draw two lines, one parallel to the left side of the shed and one parallel to the right side. Mark where these lines touch the line of the picture plane. These are the *picture plane vanishing points*.

Now choose where you want the horizon line. If an ant's-eye view is desired, you would place the horizon line very near the bottom of the shed's side view. If an elevated view is desired, you would place the horizon line high above the shed's side view. The horizon line is parallel to the edge view of the picture plane.

From the marks you made indicating the picture plane vanishing points, draw vertical lines down to the chosen horizon line. Make marks on the horizon line where these vertical lines meet it. These are the *horizon line vanishing points*.

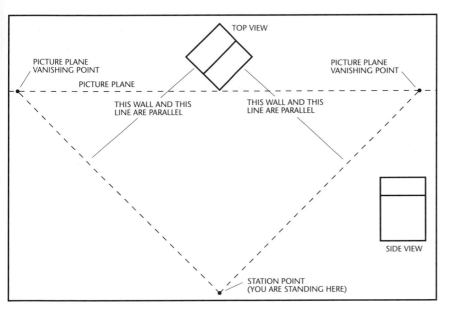

We next find the picture plane vanishing points by drawing diagonal lines from the station point parallel to the side walls of the top view. Make two marks where these lines touch the picture plane line; these are the picture plane vanishing points.

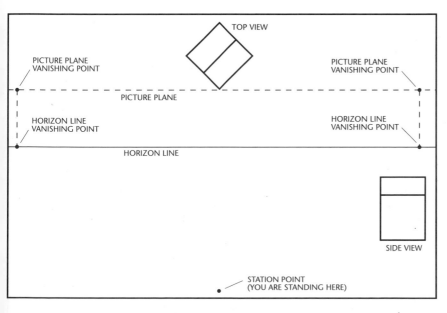

We now choose a horizon line. The higher the horizon line the more elevated our view will be; the lower the horizon line the lower our view. Bring the picture plane vanishing points straight down to the horizon line and make marks. These marks are the horizon line vanishing points.

Wall Height and Width

Now draw a ground line from the bottom of the shed's side view to the middle of the page, parallel to the horizon line. Next, draw a line from the lower corner of the top view to the station point, perpendicular to the ground line. This line represents the closest corner of the shed. On this line all true measurements are made. To determine the height of the shed wall, draw a line parallel to the ground line from the top of the wall in the side view. The distance between this line and the ground line represents the height of the wall.

To determine the width of the shed's walls, draw one line from the station point to the left-hand corner of the top view drawing, and another line from the station point to the right-hand corner of the top view. Where each of these lines intersects the line of the picture plane, make a mark. From

Draw a ground line from the bottom of the side view to the middle of the page. The ground line is parallel to the horizon line. Now draw a line from the lower corner of the top view to the station point. This will form the near corner of our shed drawn in perspective. Find the height of the shed's wall by drawing a line from the top of the side view wall, parallel to the ground line, to this corner line.

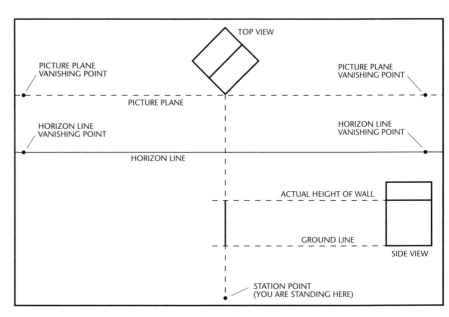

To find the width of the shed, draw lines from the station point to the left and right corners of the top view. Make marks where these lines cross the picture plane line.

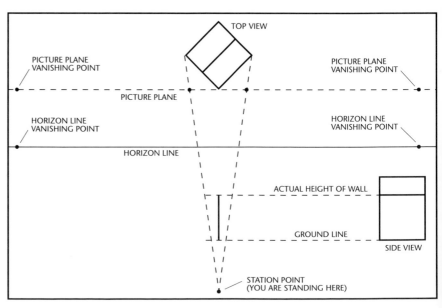

each of these marks, draw a line downward from and perpendicular to the picture plane line. These lines establish where the left and right walls end in perspective. You have now established the back corners for the left and right walls.

From the top and bottom of the front shed corner, draw lines to the left and right horizon line vanishing points. These lines define the top and bottom edges of the side walls.

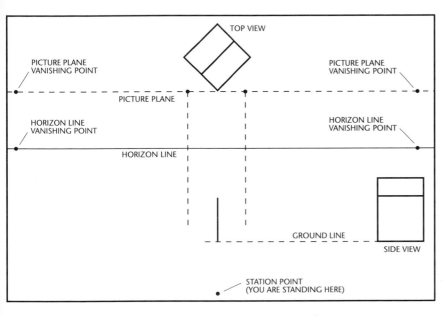

From these new marks, draw lines perpendicular to the picture plane. These lines place the side corners of the shed in perspective.

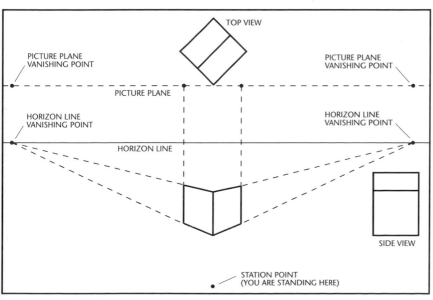

Draw lines from the top and bottom of the shed's near corner to the horizon line vanishing points to establish the left and right walls of the structure.

Roof

To establish the roof, draw a horizontal line from the top of the side view roof to the corner line of the perspective view. Where this line crosses the corner line of the perspective view, make a mark. From this mark, draw a line to the left-hand vanishing point on the horizon line. This is the perspective line of the roof.

Next, draw a line from the station point to the left peak of the roof in the top view. Where this line crosses the picture plane, make a mark. From this mark, draw a line straight down to the perspective roof line. This locates the peak of the roof. Draw in the front of the roof.

The next line to establish is the ridge of the roof. From the front peak of the roof, draw a line to the

To establish the height of the peaked roof in perspective, draw a line parallel to the ground line from the top of the side view roof to the shed's corner line and make a mark. From this mark, draw a line to the left vanishing point on the horizon line. This is the perspective roof line.

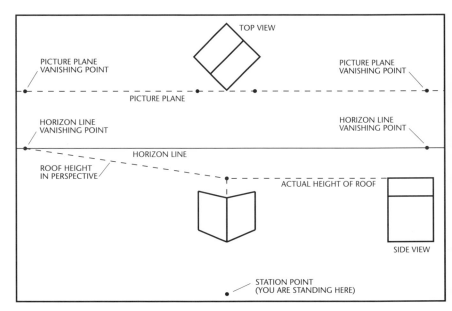

Now draw a line from the station point to the front peak of the roof in the top view. Make a mark where this line crosses the picture plane.

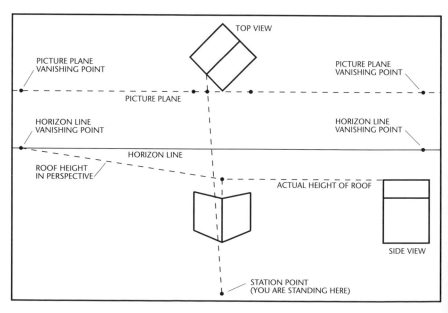

horizon line's right vanishing point.

To find the back peak of the roof, draw a line from the station point to the back peak of the roof in the top view. Where this line crosses the picture plane, make a mark. From this mark draw a vertical line down to the perspective ridge line of the shed. This establishes the back corner of the roof; your drawing is now complete.

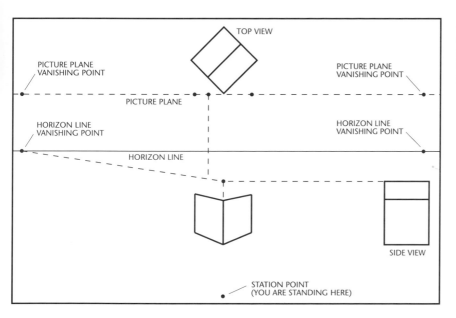

From this new mark, draw a line straight down to the perspective roof line. Where these lines meet is the peak of the roof.

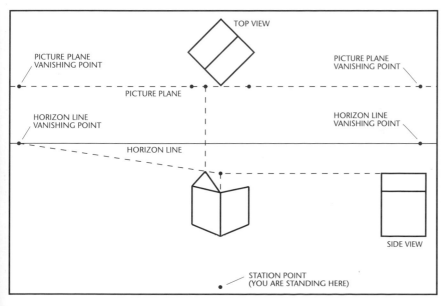

Draw the pitched roof lines to the point you have just established.

To find the back peak of the roof, draw a line from the station point to the back peak of the roof in the top view. Make a mark where this line crosses the picture plane.

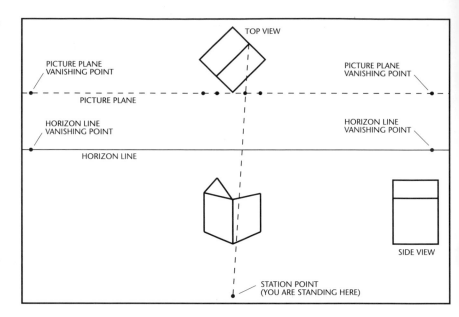

Draw a line from the front peak of the roof to the right horizon line vanishing point. This will be the roof's ridge. Then draw a vertical line down to the roof's ridge. This establishes the back peak of the roof and the length of the ridge.

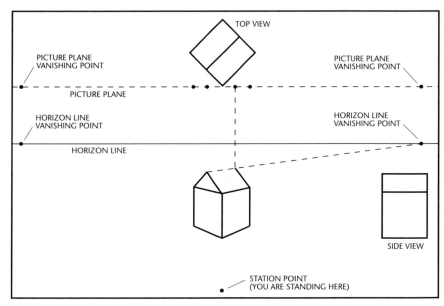

Our shed is now correctly drawn in two-point perspective.

Working with More Complex Subjects

The same principles we have just covered apply to more complex subjects as well. If you have overhead and side views (as you might find in a set of blueprints) of a subject, you can follow the steps described above to get very accurate perspective drawings. This is done by drawing lines from the station point through a picture plane to the actual locations on the overhead view and then marking the places where these lines intersect the picture plane. Lines drawn perpendicular from the marks on the picture plane will locate all of the width measurements in the perspective drawing.

All height measurements are transferred from the side view to the near corner of the perspective drawing. If a height measurement is needed for the back of a wall, you must find it first on the near corner. Then draw a line from that point to the horizon line vanishing point on that side. The heights and widths of objects appear to diminish as the objects recede in perspective; this is a way of calculating exactly how much they will be reduced. Heights and widths remain consistent between two perspective lines sharing the same vanishing point.

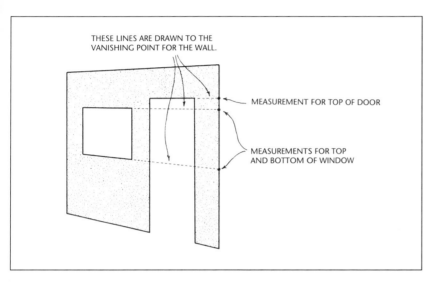

THESE LINES ARE DRAWN TO THE VANISHING POINT FOR THE WALL.

MEASUREMENT FOR TOP OF DOOR

MEASUREMENTS FOR TOP AND BOTTOM OF WINDOW

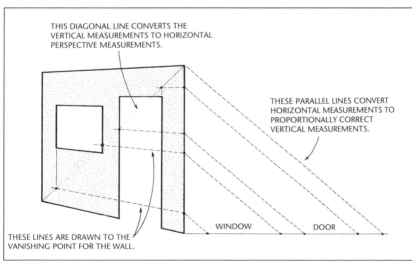

THIS DIAGONAL LINE CONVERTS THE VERTICAL MEASUREMENTS TO HORIZONTAL PERSPECTIVE MEASUREMENTS.

THESE PARALLEL LINES CONVERT HORIZONTAL MEASUREMENTS TO PROPORTIONALLY CORRECT VERTICAL MEASUREMENTS.

WINDOW DOOR

THESE LINES ARE DRAWN TO THE VANISHING POINT FOR THE WALL.

Horizontal measurements are calculated from the object's near corner. If you want to locate a door or window that is not symmetrically placed on a wall, or locate chimneys, dormers, signs, brickwork, and so on, follow these steps:

1. Start with the proportionally accurate horizontal measurements, as though the wall were parallel to the picture plane instead of receding in space.

2. Place these measurements on a horizontal ground line drawn from the lower front corner of the wall to either side.

3. Translate these measurements to the edge of the wall nearest the picture plane using parallel lines.

4. Draw perspective lines from each point of the translated measurements to the wall's vanishing point on the horizon.

5. Draw a diagonal line on the wall from one corner to another. (If you use the alternative diagonal, the measurements are reversed.)

6. Where the diagonal line and the perspective lines cross marks the placement of horizontal measurements in perspective. (You may have to use vertical lines up or down from the crossings to place window and door edges.)

Three-Point Perspective

In most situations, one- or two-point perspective is appropriate, but when a more extreme view from very low or very high is desired, three-point perspective is used.

In two-point perspective, all vertical edges are truly parallel to each other. Horizontal receding edges converge at one of two points on the horizon. In three-point perspective, the vertical edges are drawn to a vanishing point above or below the horizon. In three-point perspective there are no truly parallel lines in your drawing.

If you want to give viewers the impression of looking down on your subject, place the horizon line high on the page or even off the page. Establish vanishing points at left and right on the horizon line; the farther apart they are, the farther from the subject we appear to be standing. The edges of all surfaces (planes) parallel to the ground will converge at one of these two vanishing points. The edges of all vertical surfaces will converge at a third vanishing point placed well *below* the horizon.

To give viewers the impression of looking up at your subject, place the horizon and its two vanishing points low on the page and the third vanishing point well *above* the horizon. The edges of vertical planes converge at the vanishing point above the horizon, while the edges of horizontal planes converge at one of the two vanishing points on the horizon.

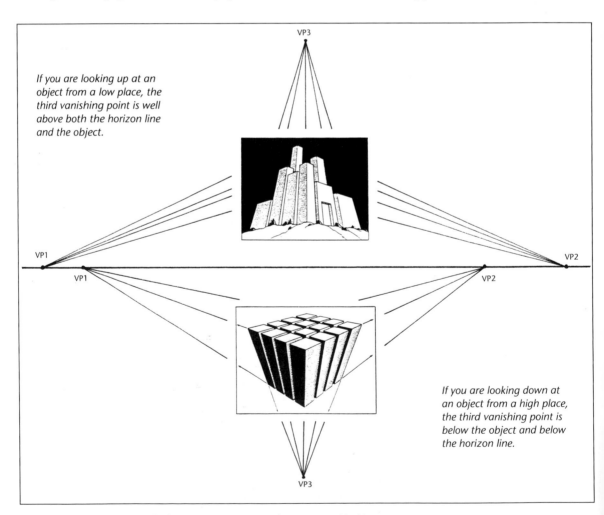

If you are looking up at an object from a low place, the third vanishing point is well above both the horizon line and the object.

If you are looking down at an object from a high place, the third vanishing point is below the object and below the horizon line.

Three-point perspective is used when you want to give the impression of looking up at a subject from a low place or down at it from a high place.

Exercises

Make two copies of the illustration shown below. On each copy, follow all the steps in the demonstration of two-point perspective on pages 96–102, but in one use a low horizon line and in the other, a high horizon line.

Paste a photograph of a building or a photocopy of the one shown below on a large piece of paper. Follow the receding lines of the building and locate the vanishing points. It would also be useful to do this with a picture of an interior.

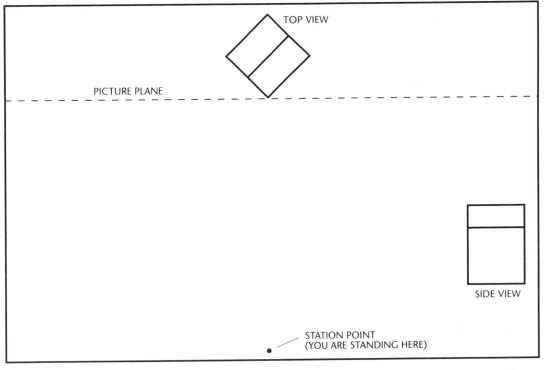

TOP VIEW

PICTURE PLANE

SIDE VIEW

STATION POINT
(YOU ARE STANDING HERE)

Make two copies or photocopies of this illustration. Follow the steps of the two-point perspective demonstration, but in one example use a horizon line that is low on the page (but not below the ground line). In the other, place the horizon line higher on the page (but not higher than the picture plane).

Photocopy this photograph or find another similar photo of a building and place it on a large sheet of paper. Extend the roof and base lines of the building to discover the two vanishing points. The horizon line intersects these vanishing points and reveals the eye level of the camera. Notice how all the parallel lines of the building share the same vanishing points.

COMPOSITION

As an artistic term, composition refers to the arrangement of visual elements on a page or a canvas. It is a tool the artist uses to express specific feelings about a subject and to guide the viewer through the artwork. An artist's message can be simply an interesting arrangement of forms, colors, or textures, or a more emotional or even literal representation of how the artist feels about a particular person, place, or thing. The important point to remember is that art is communication. For a work of art to communicate the artist's intent successfully, the first thing it must do is gain the viewer's attention, and then hold it. If a communication fails to attract attention, or after attracting attention presents a message that cannot be understood, the result is frustration for artist and viewer alike. This chapter explores the principles of composition that facilitate artistic communication.

It should be noted that composition is the most subjective of all the features of an artwork. Although many rules are presented here, they are meant only as guides and should not be allowed to inhibit your artistic expression.

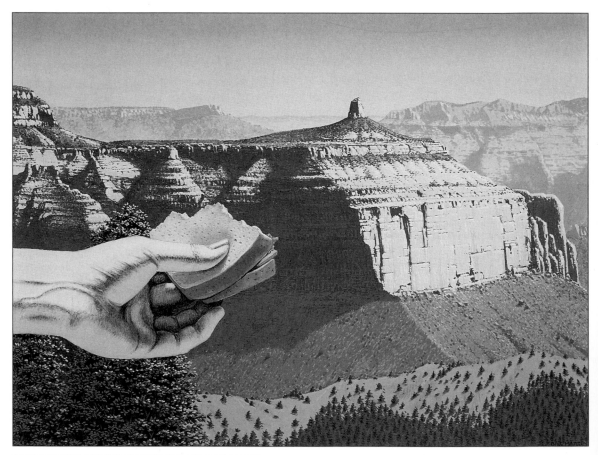

GRAND SANDWICH, GOUACHE ON PAPER, 12 X 16" (30.5 X 40.6 CM).

In this painting note how line, value, and texture have been combined to create a visually compelling composition.

Five Basic Features of Composition

There is no area within any composition that is as strong as its edge. The eye is greatly attracted to the place where the composition stops and the rest of the world begins. If interesting items in your composition are placed near a corner of your paper or canvas, the attraction is even stronger. Elements that draw attention to the edge or the corner of your paper or canvas tend to direct the eye out of the composition, and for that reason important compositional elements are rarely placed in those areas.

Besides edges, composition has four components: line, value, color, and texture. We will consider how each functions independently, and then look at how they work together as layers in a single composition. (Color is discussed in depth in the following chapter.)

The edge of the paper or canvas is one of the strongest parts of any composition. It is wise to avoid putting anything important at the edge because it will lead the eye away from the picture.

The eye is strongly attracted to corners. It is best not to further strengthen the corners by placing something interesting in them. To do so will lead the eye away from the picture.

Linear Composition

Line is second only to edge as the strongest element in compositional design. In this context, *line* refers both to actual lines and to the edges of areas of color, value, and form. Generally, a drawing begins with outlines that define these areas.

In all types of composition, variety is an excellent way to hold the viewer's attention. In linear compositions, you can achieve interesting variety in the way you control:

- the tilt and angle of lines

- the placement of intersections of lines

- the places lines touch and divide the edge of the composition

- the proportions of lines

- the proportions of areas enclosed by lines

- the distances between lines

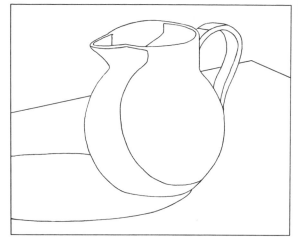

Linear composition is the thoughtful arrangement of edges and the proportions of the areas enclosed by them.

*In linear composition, **line** refers both to actual lines and to the edges of colors, shadows, and objects.*

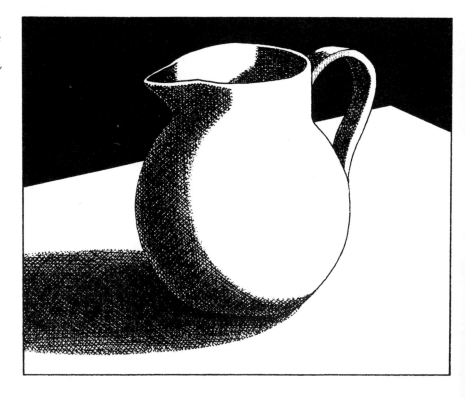

The Single Line

We will start with the simplest composition, which consists of a single straight line. As other elements are added the composition becomes more complex, but the principles and concepts that govern it remain the same.

When a single straight line is the main element in your composition, you must pay attention to these features: where the line ends, its length, its placement within the composition, and, if it touches the edge, where it touches. Let's consider first the specific effects that result from the different ways a line ends in a composition.

No matter where it is located, the end of the line is the most dramatic part of the composition and our attention is immediately drawn to it. If the line ends very near a corner (the meeting of two edges), our eye is directed out of the composition; thus, it is a mistake to place something interesting there. A line that ends in the exact middle of a composition divides it into equal parts, which is less visually interesting than an unequal division. The most visually satisfying place to end the line is where the distance from its termination to each of the composition's four edges is different. Thus, when you want to emphasize a particular element in a composition, place it where it will be at a different distance from each of the composition's four edges.

A line that touches the edge of a composition divides it into two sections. Sections of equal size are predictable, requiring less of the viewer's attention and time. Unequal divisions, however, engage the eye more, and are thus more visually satisfying. It is not how many sections the edge of a composition is divided into that matters, but the proportions of those sections; it is best when no two of the sections are alike.

When both ends of a line appear within a composition, one end is dominant and the other subordinate. The end that is located in the more aesthetically pleasing place will dominate. The most aesthetically satisfying placement is usually where the distances to the edges are varied but not extreme in their variation. Thus, when two

When you draw a single straight line in a composition, the first thing to think about is where the line ends. The end of the line is dramatic and its placement is important.

The preferred place to end a line is where its termination is at various distances from the composition's four edges.

This line ends so near the corner of the composition that it attracts our eye to that area and directs our attention out of the picture.

compositional elements are of equal interest, the element that appears in the more visually satisfying place will receive the most attention.

A line that goes from edge to edge divides the composition into two areas, which are then compared for size relationships. Variety in these and other proportions will always add interest to a composition.

The end of this line is in the exact middle of the composition and is thus equidistant from all four edges. Such a configuration holds the viewer's attention for a comparatively short time because each half of the composition predicts the other.

After considering where the line ends, we consider the length of the line and its relationship to the compositional rectangle it fits in.

Does this line require a rectangle of this size to contain it? Or is this just a small present in a big box?

This line has divided the left-hand edge of the composition into two parts. The proportions of these two parts are visually interesting because they are not equal to each other.

When both ends of a line appear in a composition, each is a point of interest. Here, the eye goes to the upper end of the line first and remains there longer because its placement is more visually satisfying than that of the lower end.

A line that crosses a composition divides the two edges it touches, as well as the whole composition. The proportions of these divisions are most satisfying when none is equal to another.

This line is placed too near the edge, creating too much emphasis in that area and thus allowing the eye to leave the composition.

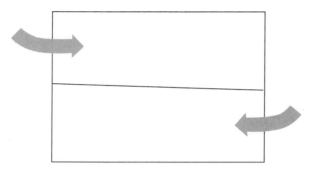

Here the line is placed too close to the middle, dividing the composition into equal parts. Equal divisions tend to be less interesting because each half predicts the other.

Two Lines

Two lines that are drawn across a composition but do not intersect divide the composition into three sections. The eye considers the relationship between these three sections and the divisions of the composition's edges, seeking proportions that are interesting. If all three sections, or even just two of them, are the same size, the composition will be less interesting than if they were all different.

Two lines that come together to make a point near or just beyond the edge of a composition form an arrow that points the eye out of the picture. If the lines form an arrow pointing to a corner, there will be an even stronger tendency for the eye to leave the composition.

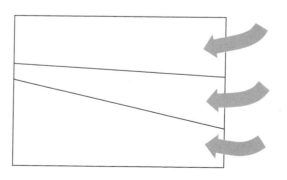

Two lines drawn across a composition divide it into three areas. In this example, the relationship of these three areas is visually satisfying. Why?

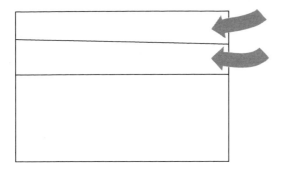

The upper two divisions of this composition are equal in size, and therefore the composition holds our attention for a shorter time than it would if all three divisions differed in size.

These lines imply an arrow pointing out of the composition. They make the right-hand edge too strong.

These lines make the lower left-hand corner stronger and thereby direct the eye out of the composition.

The line in the upper left-hand corner creates an area that is too small in relation to the other areas. Because of its unique proportions, our eye is attracted to that corner and then out of the composition.

Intersections and Irregularities

Two lines that cross in a composition prompt visual assessments of the relationship of the four areas they create, the way they divide the composition's edges, and the location of their intersection.

The intersection forms an X, which is a very powerful linear configuration because it implies four arrows pointing to the same place—a place our eye is compelled to land. The most satisfying location for such an intersection in a composition is wherever you can achieve variation among the distances from this point to each of the four edges. (The intersection should not be too close to an edge or a corner.) Artists often place an important compositional element at the intersection of an X.

All intersections of lines attract the viewer's eye, whether the lines are straight or curved. Lines that form a T, Y, or K are specific examples. Curving lines that almost touch form a near-tangent that compels the eye just as much as an intersection. The X, K, and near-tangent are stronger visual attractions than the T or Y.

In addition to these intersections, sudden changes or variations in the direction of a line attract the eye, such as the point of a V or the curve of a U. Place such intersections and directional changes where you want to direct the viewer's eye in a composition.

Two lines that intersect divide the composition into four areas. These four areas, as well as the divisions of the edges and the placement of the intersection, are the design elements to consider in this type of composition.

An X configuration in a linear composition is very strong. It implies four arrows pointing to the same place.

The intersection of the X is best placed where it will be at unequal distances from each of the composition's four edges.

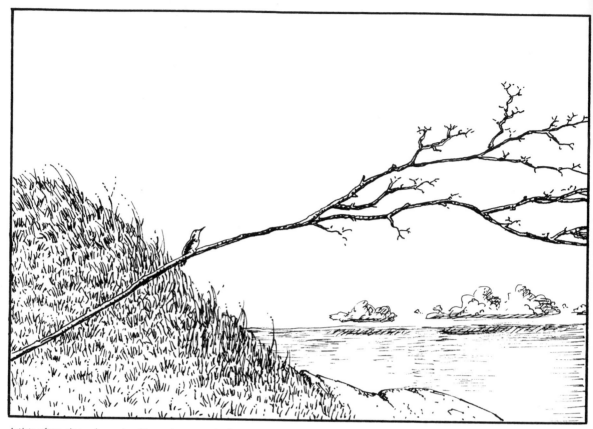

Artists often place elements of importance at the intersection of a compositional X. Although small, the bird is easily noticed because it sits right where the branch crosses the outline of the hill.

All intersections of lines attract the eye of the viewer, whether the lines are straight or curved. This is an example of a T intersection.

This is an example of a Y intersection. Because the eye is naturally attracted to them, intersections must be carefully placed in compositions.

This is an example of a K intersection.

This is an example of a near-tangent. When curving lines nearly touch they create a tension that acts like an intersection. Extra care must be used in placing near-tangents because our eye is strongly attracted to them.

This variation in the line causes our eye to linger in this area.

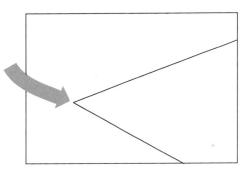

The sudden change in the direction of this line demands our attention. It is the most dramatic part of the line.

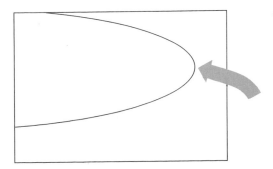

In a similar but less dramatic way, our eye is attracted to the changing direction of this line. Sharp or angular changes in direction are more compelling than gentle or rounded ones.

It is important to place the intersections of lines carefully because they attract the eye. Avoid putting too many intersections in one area, on an edge, or in the corner of the composition.

When a line comes in contact with the edge of a composition, it divides that edge. Such divisions should be unique in order to create maximum interest in the composition.

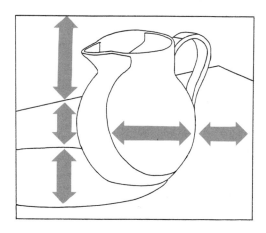

The distances between individual lines, as well as between the lines and the edges of a composition, are important. Too many lines in one area will create confusion. Lines too evenly spaced will create boredom.

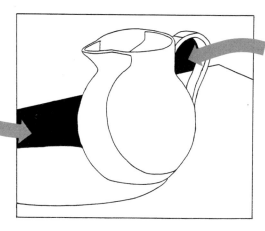

Here, compare the shapes and proportions of the areas enclosed by the lines and study their interrelationships. Variety in sizes and shapes is desirable.

Internal Harmony

Repeated shapes in a linear composition lend harmony. When there are no repeated shapes in a composition, we get the impression of agitation, uneasiness, and chaos.

For example, if we want to draw the monster that ate Chicago and convey fear and panic, irregular unrelated shapes would enhance the mood. If, on the other hand, we wish to portray the monster more sympathetically, we would choose shapes that are closely related to each other.

For greater interest and variety, you can turn, reverse, enlarge, reduce, or stretch repeated shapes. Too much repetition of a shape, especially in similar sizes, tends to create order, predictability, and sometimes boredom. The perfect balance for each picture exists somewhere between no repeated shapes and too many repeated shapes. We choose that balance by deciding what degree of anxiety or relaxation we want the picture to convey. We then organize the shapes accordingly.

The irregular, unrelated shapes of this linear composition help to heighten the feeling of uneasiness and anxiety.

This composition seems much less chaotic and the monster much less threatening than in the previous example. Internal harmony has been created through the repetition of shapes, changing the way we think about the scene.

Positive and Negative Shapes

Included in linear composition is the concept of positive and negative shapes. A positive shape is the object itself. A negative shape is what exists between and around the positive shape. Imagine a doughnut on a plate. The doughnut is the positive shape; the hole in the doughnut and the area around it is the negative shape. Positive and negative areas of a given shape or subject should be neither equal in proportion nor extreme in their variation.

The most important rule regarding positive and negative shapes is this: Complex contours of positive shape require larger areas of negative shape around them than do simple contours.

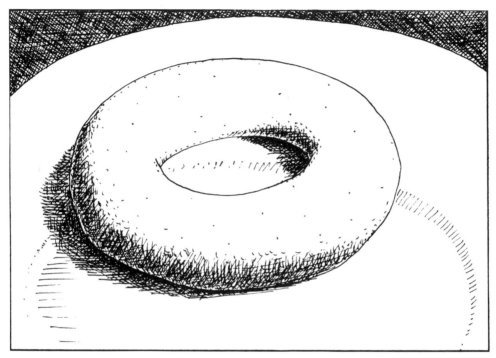

The doughnut is a positive shape. The hole in the doughnut and the area around the doughnut are the negative shapes. Positive and negative shapes should not be equal to each other or extreme in their variations.

The face is a more complex contour than the back of the head, and thus needs a larger area of negative shape around it. Can you see the imbalance in this picture?

Here the fin is a more complex contour of positive shape than the face, and consequently needs a large negative area to offset it. In this composition, the positive and negative shapes are balanced.

Four Types of Linear Composition

The contour and tilt of the lines in linear compositions create mood. The moods can be very complex but are based on the four simple principles listed below. Rarely is a composition based solely on one of these types; usually there is some combination of the four:

• When horizontal lines dominate, they create a sense of peace and relaxation. (Think of a calm ocean and the distant horizon.)

• When vertical lines dominate, they create a sense of alertness and order. (Think of soldiers standing in a row.)

• When diagonal lines dominate, they create a sense of drama and swift movement. (Think of a tree falling.)

• When curving lines dominate, they create a feeling of sensuality and leisurely movement. (Think of a round woman lolling on a curved sofa.)

In a linear composition, a great variety of expression and mood can be created by thoughtfully controlling:

• different tilts of lines

• placement of intersections

• proportions of areas created by lines

• repetition of shapes

• proportions of positive and negative shapes

• distances from elements within a composition to its four outside edges

A composition dominated by horizontal lines conveys a sense of peace and relaxation.

When vertical lines dominate a composition, a sense of alertness and order prevails.

Diagonal lines create a feeling of drama and swift movement in a composition.

Curving lines convey sensuality and leisurely movement.

The four basic types of line— horizontal, vertical, diagonal, and curved—are often used in a composition in various combinations. In this example, the vertical cacti add order and alertness to the otherwise passive horizontal composition.

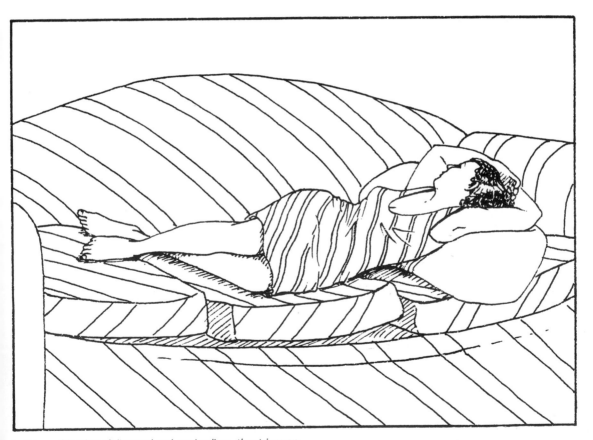

In this combination of diagonal and curving lines, the stripes on the sofa and dress lend drama to an otherwise sensual scene.

Value Composition

Value, which refers to the relative lightness or darkness of a color, is the second layer of composition. Works of art rendered in only black, white, and tones of gray rely especially on a skillful handling of value composition. Even pictures executed in full color are visualized as black-and-white photographs to assess value composition. Usually, line dominates over value, color, and texture in composition, but the power of value contrasts can sometimes mean value is the dominant layer.

You can use value to alter linear elements in a composition. For example, if your subject makes it necessary to run a line into a corner (which we've learned is not good compositional practice), value can correct this mistake. The border between two neighboring values is a line. By making those values similar, you make the line less important. If you want to emphasize a line, you instead exaggerate the value differences.

Value contrasts can affect apparent size relationships. If a gray square and a black square of the same size are placed on a white background, the black square will appear larger and more important. This is because the contrast between black and white is stronger than that between gray and white. Also thanks to contrast, a small dark object and a large light object seen together against a light background will appear to be in balance; conversely, a small light object can balance a large dark object on a dark background.

In a linear composition, areas of equal size can be uninteresting. But introducing a high contrast between two areas can create the appearance that one is of a different size, thus making the proportions seem more interesting. By the same token, compositional areas that are well balanced in terms of line can lose their balance when a strong value contrast is introduced too close to the edge or corner of the composition.

Thus, what is wrong with the linear aspects of a composition could actually be right when adjusted with value. And, what is right with line could actually be wrong if the value contrasts are out of balance.

When you wish to emphasize a particular area or object in a composition, create strong value contrast near it. You can also arrange the edges of values to guide the eye to the area of greatest importance. These kinds of devices can be used to guide the eye in a specific sequence. To make a point quickly, draw the viewer's attention to the most important thing first. Other areas of emphasis are then used to augment the first. If you want to begin by setting the mood and then reveal the main point, you draw the viewer's attention through a series of areas of interest that lead to the significant part.

Value can be used to alter linear compositional elements. In this example, the awkwardness of the line running to the corner is minimized by reducing the value contrast in that area (A). Another part of the line is emphasized by exaggerating the value contrast around it (B).

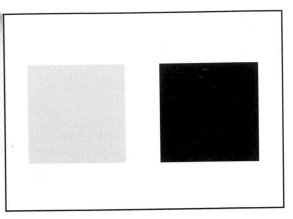

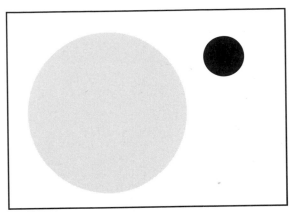

Value contrasts can affect apparent size relationships. Although it is the same size as the gray square, the black square appears larger and more important because it is in higher contrast with the white background.

Because of its greater contrast with the background, the small dark circle balances with the large light circle.

Although the proportions of its linear elements are good, this composition is out of balance because the value contrast at right is too strong.

In this example, although the upper two shapes are the same size (which would be undesirable if the composition were solely linear), the value contrast creates the illusion that they are different and thus makes the composition more interesting.

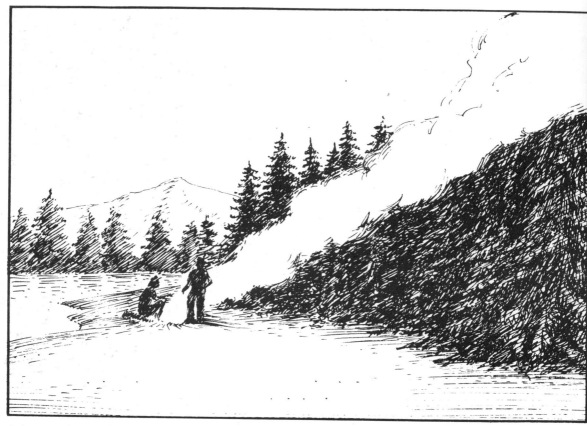

Artists use value to call attention to important details in a composition. Here the light column of smoke and the dark triangle of the trees draw our attention to the two small figures.

If it is desirable to set the a mood of a picture first and then reveal the meaning, you can create a series of areas of interest that lead to the significant part. Here the flowers are the first things we see, and they set the mood. Only after a moment or two do we see the romantic snakes.

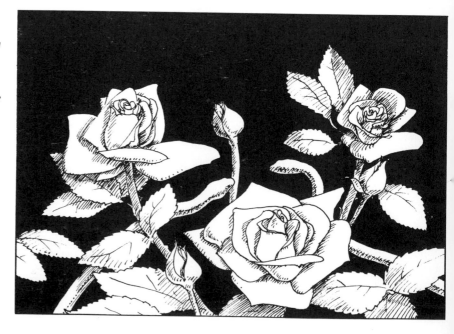

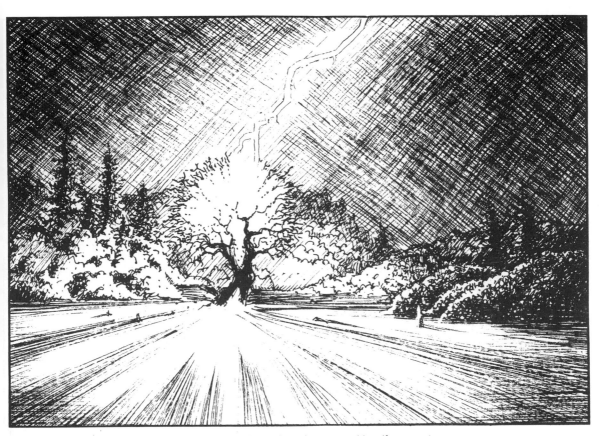

By using just value and line you can direct the viewer's eye through a composition. If you want
the viewer to understand the picture quickly, make most lines point to, and value contrast
greatest at, the important area, as in this example.

Texture Composition

The third layer of composition is color, which we will explore in detail in the next chapter. Thus, we proceed to the fourth compositional layer, texture. In this context texture refers to visual patterns as well as the physical, tactile texture of an object's surface. A field of rocks is both a visual and a tactile texture, whereas a sky full of small clouds is a purely visual texture, since clouds simply feel like air. A checkered tablecloth is another example of a purely visual texture.

Using texture in composition involves handling the balance of texture and no texture; degrees of textural complexity, both visual and physical; and patterns that convey the nature of specific surfaces, for example, using lines for grass, dots for gravel, diamonds for a checkered tablecloth.

What we seek is interesting variation in the shapes of textured areas, their patterns, and placement in the composition. Areas of complex visual texture will attract the eye; the more complex the texture, the stronger the attraction. However, placing most of the texture in an awkward area of the composition creates an imbalance that can direct the eye away from the picture. If all the texture is on one side and the weight of the negative space does not balance it (it usually takes a lot of empty negative space to offset a complex visual texture), the viewer's eye will travel away from the picture. Generally, though, texture placed at the bottom of the composition is less likely to lead the viewer out of the picture; for example, a hillside full of wildflowers (a complex visual texture) placed at the bottom of a composition is easily balanced by a cloudless blue sky above. A composition with a craggy vertical cliff face on one side and a cloudless sky on the other is a more difficult situation.

The fourth compositional layer is texture. In this context, texture refers to visual patterns as well as actual surface textures. Here, the rocks are both a tactile texture and a visual texture, while the clouds are a purely visual texture.

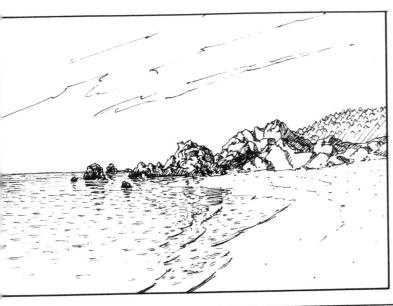

Complex textures hold the eye longer than simple textures. For that reason, in this composition we spend more time looking at the rocks than the water.

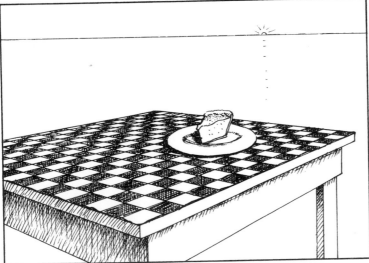

A checkered tablecloth is another example of a visual texture.

In this example all the visual texture is on one side of the picture, resulting in an imbalance—our eye is drawn to the left side of the composition with no reason to go back. Can you see how the eye is locked in the corner?

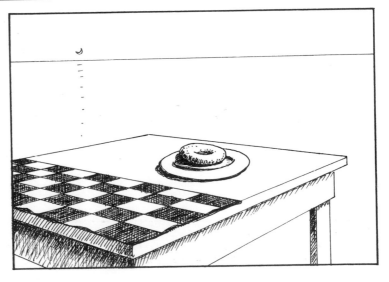

The cliff face on the left side of this composition is a complex texture; the right side of the composition is a blank sky with no texture. Balance in this situation is more difficult to achieve than in the previous example. Is this composition balanced?

It is usually awkward to have all the texture in one part of the composition. An exception to this is when the texture is at the bottom. In this case the complex texture of the flowers does not direct our eye away from the picture, but holds our attention.

The Vignette Composition

A vignette composition is one that has no linear connection to the edges of the picture; the image seems to float in the middle of the paper or canvas. The vignette composition is the weakest of all the types, and is used primarily when a feeling of softness and gentleness is desired; the borders of an image become soft-edged and fade into the background, as in greeting cards. Vignetting may also be used to separate a subject from its environment to increase its importance, as in a portrait; in many of Rembrandt's portraits, for example, the face emerges dramatically from a dark background.

Thus, in order of importance, the four main elements of composition are line, value, color, and texture. If these aspects are well thought out, first individually and then as a unit, effective compositions should result. You can influence a viewer's response to your work by using these tools expertly and with a little personal creativity.

A vignette composition is one whose linear and value elements have no connection to the edges. It is used when gentleness and softness are desired. It can also be used to isolate an important subject, as in a high-contrast portrait in which a face emerges from darkness.

Exercises

Analyze the compositions of various pictures. Determine whether the composition chosen is the most effective for the subject and what, if anything, you would change to make it better.

Cut several rectangles in proportions you like to work with from black, white, and gray paper. Now, from the same kinds of paper, cut smaller shapes to use as compositional elements on these rectangles. Make both basic and odd shapes—the more the better. Include long, thin shapes that can represent lines. On your rectangles, arrange selections of these shapes into various abstract compositions. Do not glue them down! Rather, continue to add, remove, and rearrange elements and observe your own responses to different combinations of negative and positive elements, contrasts, angles, lines, intersections, divisions of edges, and textural patterns.

Cut the shape of an object from a magazine or catalog. Then find the perfect rectangle for this shape: Balance the correct amount of negative space with the complexity of the object's contour.

COLOR

Before studying the effects of color on composition, we need to see how color works.

Sir Isaac Newton realized that the colors of the spectrum could be seen as a circle, and thus the color wheel was invented. It has long been very useful to artists as a convenient means for organizing color relationships. Here is how it works: Yellow, the color whose value is the lightest, is placed at the top. Next is orange, then red, then violet—the darkest-value color, and therefore at the bottom of the wheel. From violet we go to blue, then green, then back to yellow. There are many gradual transitions between each of these colors. The name of a color, whether it is light, dark, or neutralized, is its *hue*.

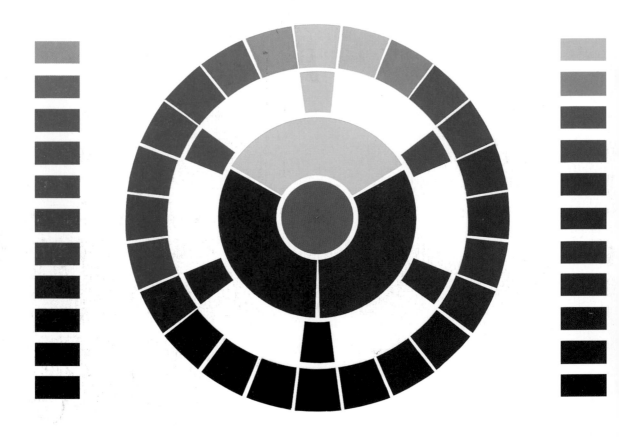

Artists use the color wheel as a guide for mixing colors. To the left of the wheel are cool colors; to the right are warm colors.

Basic Color Theory

Red, yellow, and blue are called primary colors because they cannot be mixed in their pure state by combining other colors. Green, orange, and violet are called secondary colors because each is a mixture of two primary colors. Blue and yellow combine to make green, red and blue combine to make violet, and yellow and red make orange. These are placed in a circle, with the secondary colors between their component primary colors. Colors located between a primary and a secondary color are called tertiary colors. They include yellow-green, red-violet, blue-green, and so on. The subdivisions of the color wheel are continued for as long as there is a perceptible difference between two colors.

Warm and Cool Colors

The color wheel is divided into what are considered warm and cool colors. In the illustration on the opposite page, the warm colors are those to the right of yellow at the top and violet at the bottom; cool colors are those to the left of yellow and violet. Pure violet and pure yellow are neither warm nor cool; they represent the borders between the two divisions. A yellow with the smallest amount of orange in it is considered warm, while a yellow with the smallest amount of green in it is considered cool. A reddish violet is warm, a bluish violet is cool. Warm and cool are relative terms, of course; a warm color located near the border between warm and cool is said to be cooler. For example, orange is a warmer color than yellow-orange, while blue-green is cooler than blue-violet.

Color Values

Yellow is the lightest-value color, violet the darkest. Red and green are middle values. Pure reds and oranges are so intense they are sometimes mistakenly used as highlight colors, but they are actually middle values and should not be used for highlights except on objects so dark that middle values look light. It is important for artists to be aware of a color's value. A painting in which the colors are wrong but the values are right will look better than one in which colors are right and values wrong. As a compositional element, value carries more weight than color.

A color with white added to it is called a *tint*. A color with black or its complement added to it is called a *shade*.

The color yellow is the lightest in value; violet is the darkest. Red and green are middle values.

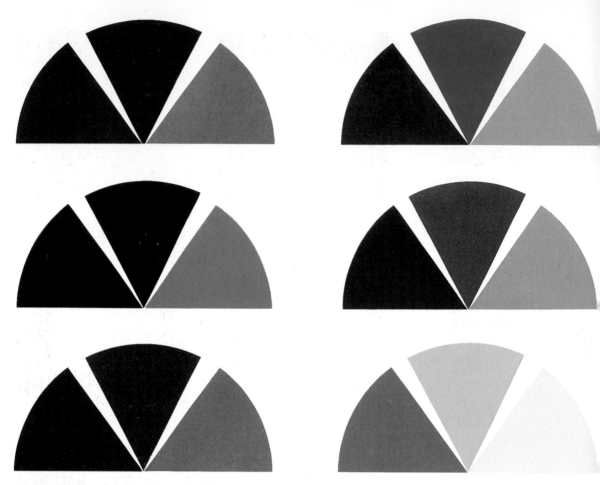

Here, each of the primary and secondary colors is accompanied by a tint (to the right of each hue) and a shade (to the left of each). A tint is a mixture of a pure color and white; a shade is a mixture of a pure color and black. It is helpful when you are mixing colors to see the pure color within its tint or shade.

Complementary Colors

Colors opposite each other on the color wheel are said to be complementary. Red, for example, is opposite green and is therefore green's complement. Blue and orange, yellow and violet, and blue-green and red-orange are other complementary pairs. When complementary colors are placed near each other they appear brighter and more intense than when placed near any other colors. Red looks redder near a green, and vice versa. Warm and cool colors accentuate each other in a similar way, although not as strongly.

Color Intensity

A color is at its most intense when pure—when it is not a tint or shade. Adding black, gray, or white means the color becomes less intense but retains its original character. For example, red with some white added is still red, but a less intense red. (Adding another color to the red—say, yellow, changes its hue to orange.) Adding a small amount of the color's complement to it also lessens its intensity, or neutralizes it, without changing its essential hue.

In theory, any two complementary colors mixed in equal proportions will produce gray, the most neutralized a color can become. (In practice, due to the variability of pigments, this is rarely the case.)

Note what happens when we place each of the six hues of the color wheel—the three primaries and the three secondaries—against its complement. A color seems most intense when juxtaposed with its complement.

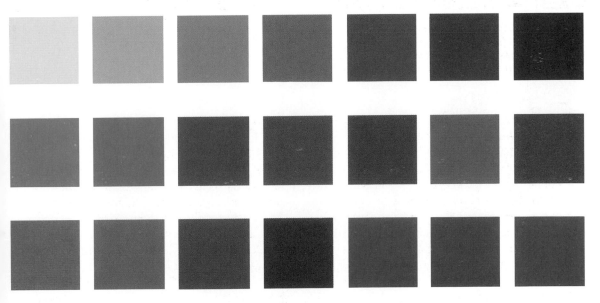

Theoretically, equal mixtures of complements will produce gray. Here, colors on the left are mixed in gradual steps with those at right, their complements. Note how the intensity of a color is reduced when some of its complement is added to it. This neutralizing effect is useful when you want to make a color appear to recede in a composition, or convey specific effects of light and shadow on a color.

Neutralized Color

To convey distance, color is used at its most intense in the foreground of a composition and is diminished in intensity as it recedes toward the background. This is especially effective when you want to indicate the distance between two objects of the same or similar color.

Imagine a field of yellow-orange poppies all in the same light. The poppies in the foreground are purer—more intense—in color than those in the background. As they recede farther into the distance, they appear more neutral in color. In a painting, you can achieve this by adding trace amounts of the color's complement to neutralize it. All neutralized colors will, when compared to their purer form, appear to recede. Adding black, white, or gray is another way to neutralize a color, but a less effective and less elegant one.

POPPIES, OIL ON CANVAS, 24" (61 CM) DIAMETER.

The color of the poppies is more intense (purer) in the foreground than in the background, where their color has been neutralized slightly by the addition of its complement. When you add to a given color a trace of its complement, the color appears to recede.

Color in Light and Shadow

Colors become neutralized in bright light, in shadow, in cast shadows, and in objects seen behind glass, under water, or in the distance.

The color of the light changes the color of the object. Sunlight is a pale yellow-orange. Light on an overcast day is blue-gray. A green tree in sunlight will appear more yellow-green than the same tree in overcast light, which will seem more blue-green. In painting, the color of the light is added to the light side of the objects depicted.

The color of a shadow or cast shadow includes the complement of the color of the light. For example, if the sunlight in a particular scene is yellow-orange, the shadows and cast shadows of objects illuminated by this sunlight will include blue-violet (the complement of yellow-orange). As the sun sets it often creates an orange light; the next time you see this happen, watch the cast shadows on a white surface turn blue.

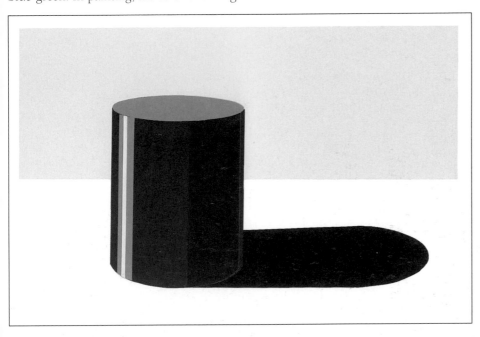

This red cylinder is illuminated by yellow light. Violet, the complement of yellow, is added to the shadow side of the cylinder, where it mixes with the form's local, or actual, color to become a muted red-violet. The cylinder's cast shadow on a white surface has much violet in it.

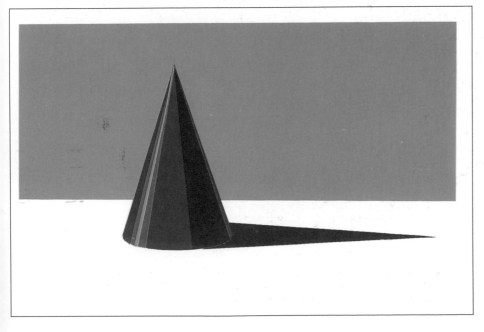

This red cone is illuminated by blue light. Its shadow side has orange added to it, as does the cast shadow. Look for the complement of the light's color in shadows and cast shadows.

Color Relativity

Colors are greatly influenced by the value and hue of colors around them, as the illustrations on these two pages show. When it is important that a color appear the same in areas with different color or value backgrounds, it is necessary to alter the original color so that it appears to stay the same. (You have to lie to tell the truth.)

Notice how four identical orange squares appear to differ from one another when placed against backgrounds of different colors.

Note how the red-violet shape appears to be redder against the blue half of the background and bluer against the red half.

Cover the top part of the yellow-orange shape with your hand and note how the remainder appears to change value against the different backgrounds.

At first glance the blue diamonds appear to be the same color, but if you look along the bottom margin, you will see that they are not identical. The blue at right, against the violet background, has been slightly altered to make it appear the same as the blue at left. The alteration compensates for the effects caused by the different background colors.

Pigments

In identifying or mixing any color, there are only three variables: its hue, such as red, red-violet, blue-green, and so on; its value, or relative lightness or darkness; and the degree of neutralization (how much of the color's complement is added to it). With just these three controls, all colors can be found. Pigments, however, being imperfect, can have an effect on this system, so familiarity with their idiosyncrasies remains a necessity.

Pigments are the ingredients that provide the color in paints, pastels, pencils, and other art mediums. They are added to various vehicles for ease of application: to water and gum arabic to make watercolors, to linseed oil to make oil paints, to polymer emulsion to make acrylics, and to clay for pastels and colored pencils. Most, though not all, pigments are compatible with most vehicles.

Here are some examples of how pigments can vary. You may think one red is interchangeable with another, but that's not the case. Cadmium red is a bright permanent red, but when combined with a blue, it makes a very muted violet. Another red, alizarin crimson, makes a brilliant violet when combined with a blue. If you use ivory black to darken a yellow, you will create a green; instead, try adding a burnt umber or a violet. To avoid the greenish color that can result when you darken an orange with black, use burnt umber instead. Transparent colors such as alizarin crimson and phthalo green change character when white is added to them. It is a great help to know what your colors will do before you begin your masterpiece. For each medium you use, make a chart combining your colors in all possible ways.

BUTTERFLIES, OIL ON CANVAS, 24" (61CM) DIAMETER.

The neutralized colors of the background, in conjunction with the intense colors of the foreground, give this painting its illusion of depth. It is important to become familiar with the way pigments behave alone and in different combinations, both physically and visually, so you will know how to use them to create the specific effects you are after.

Color in Composition

As noted in the previous chapter, color is the third layer of composition. For our purposes black, gray, and white are considered values, not colors; thus, a picture rendered only in these tones does not use the principles of color composition. As we saw in the previous chapter, there are specific ways to handle line, value, and texture in composition that draw the viewer in and convey the artist's message successfully. So, too, with color, in terms of both placement and combination.

A color that is unlike any other in a composition will draw attention and therefore requires careful placement. Use a unique color where you want to direct the viewer's eye. You can also use a unique color as an accent to enliven a picture. If a unique color is placed too near an edge or a corner, the eye will be attracted there and thus leave the composition. If such an awkward placement is unavoidable, it is helpful to place another unique color in a position opposite the first. For example, if a unique color directs the eye to the extreme right side of the composition, another unique color on the left side will help to bring it back.

There are many ways to organize the colors in a composition, but essentially there are just four basic schemes: monochromatic, complementary, analogous, and triadic. These four are adequate for most situations, and each has its own influence on the mood of a picture.

Monochromatic Color Schemes

Monochromatic means one color and includes the light, middle, and dark values of that color. There is usually no difficulty in harmonizing a monochromatic color scheme and little concern about the placement of odd colors. The mood created with this scheme is usually simple and direct, and its specific meaning depends on the color chosen. For example, using mostly middle values of a yellow-orange conveys a sense of pervasive warmth and security. It would be difficult to create a frightening picture using this color without dramatically shifting the values and/or using a lot of diagonals in the linear composition. Using blue-green, however, would result in a feeling of cool detachment, while red-violet would suggest sensuality. The meanings of colors are, of course, subject to personal, political, and cultural interpretation.

MORNING DEW,
GOUACHE ON PAPER,
12 X 16" (30.5 X 40.6 CM).

This is an example of a monochromatic color scheme. One dominant color is used, along with its tints and shades.

Complementary Color Schemes

As we have seen, colors directly opposite each other on the color wheel are called complements. A color will appear its strongest and brightest next to its complement. Thus, a complementary color scheme is used when strong impact and drama are desired. Complements can be used as accents, as in a small red ball on a large green field, or used as near-equals, as in autumn's orange leaves against the blue of the sky. In both cases the intensity of each color is increased by the presence of its complement. Complementary colors need not be of similar value or intensity to enhance each other or function effectively in a composition. For example, a dark, muted blue will still complement a bright orange. Even two muted complements will accent each other.

Warm and cool colors can also complement each other. For instance, blue is a cool complement to red's warmth. This is not as strong a relationship as the contrast between two true complements, such as blue and orange. Yet juxtaposing colors of different temperatures can result in interesting compositional effects with impact and drama.

A variation of a complementary color scheme is the *split-complementary* scheme. For example, red and green are complementary colors; a split-complementary color scheme based on those colors would include red plus yellow-green and blue-green, or green plus red-violet and red-orange.

Orange and blue are the dominant colors in this complementary color scheme. I chose these colors to give extra strength to what is actually a very simple composition. In this and the following accompanying diagrams, color names are abbreviated this way: Y=yellow, R=red, B=blue, O=orange, V=violet, G=green, YO=yellow-orange, and so on.

VERY COLD WATER, GOUACHE ON PAPER, 16 X 12" (40.6 X 30.5 CM).

ARTIST'S CACTUS, GOUACHE ON PAPER, 12 X 16" (30.5 X 40.6 CM).

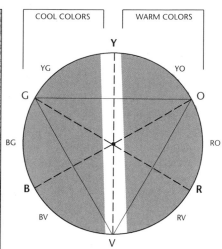

To emphasize the importance of the flowers in this painting, I heightened the intensity and warmth of their red-violet color by juxtaposing its cool complement, blue-green.

CYNTHIA'S LEAVES, GOUACHE ON PAPER, 12 X 16" (30.5 X 40.6 CM).

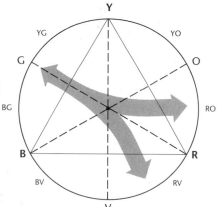

To depict the fallen leaves from my sister-in-law's tree, I used a split-complementary color scheme of red-orange, red-violet, and green. Adding some green leaves to the composition provided an accent and intensified the other colors.

Analogous Color Schemes

Colors close to each other on the color wheel are called analogous. For example, red, red-orange, and orange represent an analogous group. Analogous colors have the built-in harmony of a shared color; in the example given, all three colors have red in common. An analogous color scheme uses three to five neighboring colors on the color wheel. As with monochromatic color schemes, analogous colors create simple moods in a composition. However, while a monochromatic scheme can sometimes look like a black-and-white picture that has been toned with a single color, an analogous scheme involves a greater range of colors, allowing for increased subtlety and emotional expression. Blues and violets tend to create a quiet, somber mood; reds, yellows, and oranges tend to create cheerfulness and exuberance; greens imply calm. Occasionally a color from the opposite side of the color wheel is used as an accent.

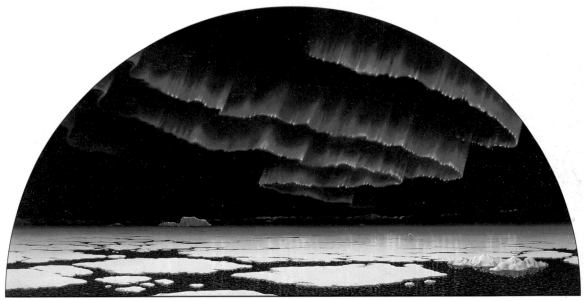

AURORA, OIL ON CANVAS, 30 X 60" (76.2 X 152.4 CM).

To convey the coldness and quietness of this subject I used a cool analogous color scheme consisting of blue, blue-violet, and blue-green.

Triadic Color Schemes

Any three colors that form an equal-sided triangle on the color wheel are considered triadic. Red, yellow, and blue is a triadic color scheme, as is violet, orange, and green. Triadic colors tend to create a mood of cheerfulness and buoyancy, which is why they are often used in children's toys. The purer (more intense) the colors are, the more pronounced the effect.

Numerous variations in color composition are possible. In a composition that uses many colors, those that dominate define the main color scheme; other color schemes may be used in conjunction with the principal one for special effects. An awareness of the effects color has on you and your audience is a necessity. And, as with the linear, value, and textural elements of composition, the sizes and shapes of colors are most interesting when they are varied. Generally, some repetition of colors will add internal harmony to the composition.

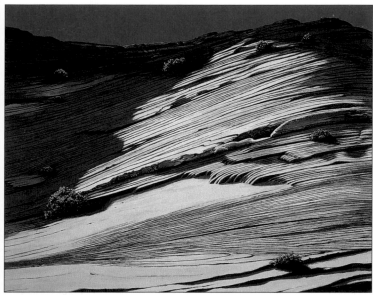

PETRIFIED SAND, GOUACHE ON PAPER, 12 X 16" (30.5 X 40.6 CM).

Although the scene itself dictated my choice of colors, a triadic scheme of red, yellow, and blue, I decided to emphasize the colors' strength to make the viewer feel good about rocks.

Exercises

Create a color chart for each of your mediums. Include the light and dark versions of each color and record what colors you used to achieve these mixtures.

Make a swatch of a pure color. Then make another swatch of the same color and add the smallest amount of its complement to it. Make another swatch, adding more of the complement. Notice how the neutralized colors appear to recede.

Using scraps of colored paper, create several abstract compositions and see what emotions and impressions specific color combinations evoke in you.

Conclusion

My intention in this book has been to explain how I see and think in the world of vision, and to offer this view for your use until you have your own. The creation of art is an immense pleasure in my life. To give this pleasure to another is my welcome reward.

Index